Long Beach

IN VINTAGE POSTCARDS

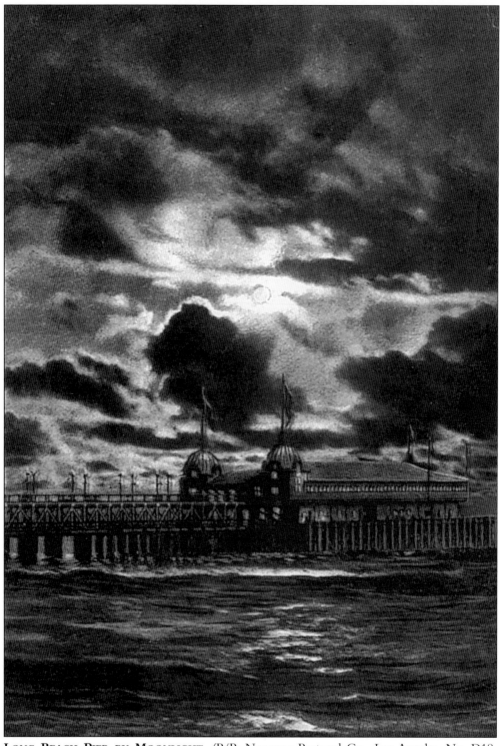

LONG BEACH PIER BY MOONLIGHT. (P/P: Newman Postcard Co., Los Angeles, No. D18. Postmark: February 1914.)

POSTCARD HISTORY SERIES

Long Beach

in Vintage Postcards

Marlin Heckman

ARCADIA

First Printed 2000.
Reprinted 2002, 2003.

Published by Arcadia Publishing,
an imprint of Tempus Publishing, Inc.
Charleston SC, Chicago, Portsmouth NH,
San Francisco

Printed in Great Britain.

Library of Congress Catalog Card Number: 00-107497

For all general information contact Arcadia Publishing at:
Telephone 843-853-2070
Fax 843-853-0044
E-Mail sales@arcadiapublishing.com
For customer service and orders:
Toll-Free 1-888-313-2665

Visit us on the internet at http://www.arcadiapublishing.com

IN LONG BEACH

It's fun to be a tourist
And with the tourists stand,
A happy smile upon your face,
A guide-book in your hand;
A yellow poppy on your breast,
Orange blossoms in your hair,
Ramona handy in your grip,
Time-tables everywhere.

It's fun to be a tourist
To climb these mountain walls,
To visit countless canyons
With streams and waterfalls;
To see them all, then gaily
Down to the beach to trip,
And in the old Pacific
Take your initial dip.

It's fun to be a tourist,
Your first orange grove to see,
To eat your first ripe olive
Fresh picked from off the tree;
To gaze upon the date-palms,
And eucalyptus trees,
And at the graceful peppers
Slow swaying in the breeze.

It's fun to be a tourist,
An ostrich farm to view,
To see the ancient missions
And modern oil well, too
To buy a bunch of post cards,
A thousand at the least,
To send to friends of old lang syne,
Who still are in the East.

Copyright June,1913, by H.C Hurst

HAVEN CHARLES HURST

IN LONG BEACH, A POEM BY HAVEN CHARLES HURST. (P/P: Token Post Card Co., Los Angeles. Copyright, June 1913, by H.C. Hurst. Postmark: November 1919.)

Cover photo: AUDITORIUM, LONG BEACH, CALIFORNIA. This was a social gathering place for the community and tourists alike. (P/P: Benham Co., Los Angeles. No. 2312.)

CONTENTS

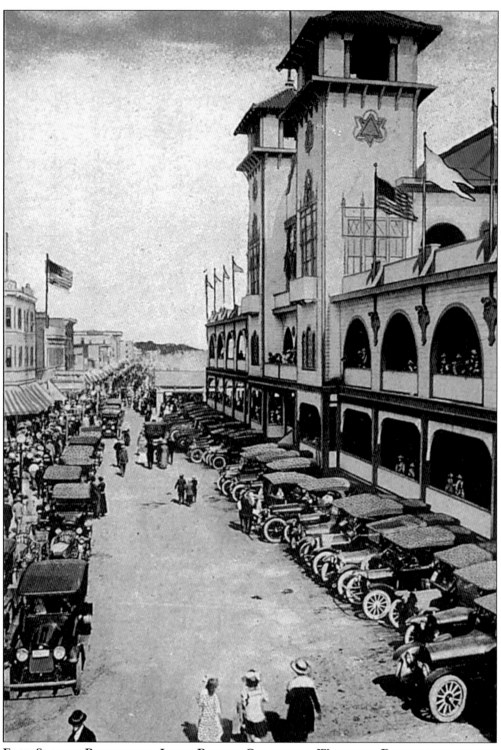

EAST SEASIDE BOULEVARD, LONG BEACH, CALIFORNIA WITH THE BATHHOUSE ON THE RIGHT SIDE OF THE STREET. (P/P: M. Kashower Co., Los Angeles. No. 264.)

INTRODUCTION

Long Beach, California, was also known as the Queen of Beaches, and its fame spread far. Long Beach is located on a bluff overlooking the sandy shore of the Pacific Ocean and enjoys a temperate climate.

In 1882, William Willmore, a land developer, planned Willmore City along the coast, south of Los Angeles. The development failed, but in 1888 the City of Long Beach was incorporated on the same site, named for its expanse of over 5 miles of beaches.

In the last decade of the 19th century, competition between the Santa Fe and Southern Pacific Railroads brought large numbers of visitors to Southern California and to Long Beach. In 1902, the completion of the Pacific Electric railway line from downtown Los Angeles to Long Beach made the city of Long Beach an even more popular tourist attraction and afforded easy, inexpensive access for many people.

Resort hotels and apartment buildings were built along the shore, and people came to stay for the winter season. "Mrs. Fanny Preston, of Boston, just came for the winter season of 1916 but stayed on until 1927. She dined at the same table, served by the same waitress for ten years." (Loretta Bruner, *Shades of the Past*, Historical Society of Long Beach, 1995, p. 14.)

A series of pavilions, auditoriums, and band shells brought many to Long Beach to enjoy various cultural activities. Long Beach was the first city in the country to have a year-round municipal band, financed by the city.

Colonel Charles R. Drake arrived in Long Beach from Arizona in 1901, expecting to retire but "spent the next 30 years tirelessly building its beach into one of the most popular and long-running recreational meccas on the west Coast." (Charles Queen, *Long Beach and Los Angeles: A Tale of Two Ports*. Northridge, CA: Windsor Pub., 1986, p. 69.)

In 1902, Col. Drake built the bathhouse, an example of Grecian Architecture costing nearly $100,000. It included dressing rooms and an 82-degree saltwater plunge. According to a 1904 tourist booklet, "Outside of San Francisco, it has no equal on the Pacific Coast." The same tourist booklet also carried the following lines about the bathhouse: "Behold your lofty portico stately colonnade where the builder has his skill displayed. Through whose damp runways every

moment press women with damp attire, men with less. . ." About 1907, Charles Drake also began an amusement park which he named "Walk of a Thousand Lights," but which was more commonly known through the years as the Pike. The Pike included all sorts of carnival-type rides and amusements, along the edge of the sand and waves. Over more than 60 years, three different roller coaster structures were built at the Pike, over the sand, within earshot of the pounding surf.

An interesting chapter of Long Beach history involved the short-lived beachwear ordinance which went into effect in 1920 but was rescinded in 1923. William Peek, a local mortician, was the author.

No person over the age of six shall appear on any highway or public place or on sand or beach or in the Pacific Ocean in Long Beach clothed in a bathing suit which does not completely conceal from view all that portion of the trunk of the body of such person below a line around the body even with upper part of the armpits except a circular arm hole for each arm with the maximum diameter no longer than twice the distance from the upper part of the armpit to the top of the shoulder and which does not completely conceal each leg from the hip joint to a line around the leg one-third of the way to the knee, and without such bathing suit having a skirt made of opaque material surrounding the person and hanging loosely from the waistline to the bottom of each suit. Every person violating any of the provisions of this ordinance shall be deemed guilty of a misdemeanor and upon conviction thereof shall be punished by a fine not exceeding five hundred dollars or by imprisonment in the city for not more than six months, or by both such fine and imprisonment.

Charles Queen suggests that, "Having delivered himself of this masterpiece, Mr. Peek presumably returned to his somber duties at the funeral home while the townsfolk came up with various interpretations of the new law. Some of them were still trying to figure it out three years later when the ordinance was repealed, bathing suits were carved down to fit the figure, and women were given a fighting chance to swim rather than sink." (Charles Queen, *Long Beach and Los Angeles: A Tale of Two Ports*. Northridge, CA: Windsor Pub., 1986, pp. 86,87.)

The final decades of the 20th century brought many changes to Long Beach, including the closing of the Pike, partially due to larger and grander amusement parks in other parts of Southern California. Redevelopment along the shoreline has meant that the 1933 Municipal Auditorium, with its Rainbow Pier and Lagoon, has been replaced by the large Convention Center and Performing Arts Complex. The ocean-going *Queen Mary* was purchased by the City of Long Beach and continues to be a tourist attraction and hotel. A new aquarium opened in 1999. Conventions continue to bring tourists to Long Beach.

As an aid to deltiologists (postcard collectors) the abbreviation P/P identifies known publishers/photographers for each card, and there is an index for those entries. Postmarks are also noted, for postally-used cards.

One
LONG BEACH,
CITY AND PORT

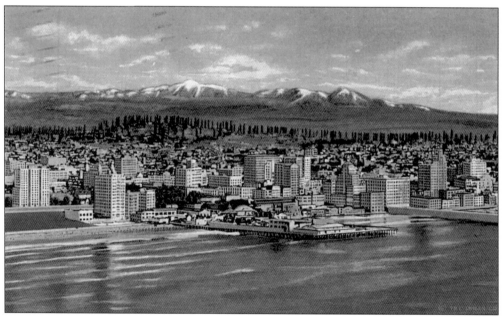

THE CITY OF LONG BEACH, CALIFORNIA. SIGNAL HILL OIL DISTRICT IN THE
BACKGROUND. "OLD BALDY" AND THE SIERRA MADRE RANGE IN THE DISTANCE. Text
on the card reads: "This remarkable picture will give some idea of the amazing growth of this
charming seaside city. The famous Signal Hill Oil Field may be seen in the near distance. In the
far distance, from 50 to 75 miles away, may be seen the majestic snow-capped Sierra Madre
Range with 'Old Baldy' in the center." (P/P: Western Publishing & Novelty Co., Los Angeles.
No. L8. Postmark; 1952.)

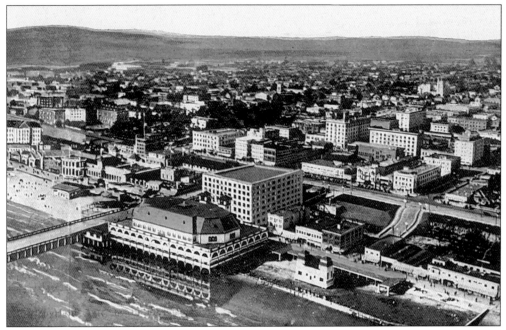

LONG BEACH, CALIFORNIA FROM AN AEROPLANE. (P/P: Edward H. Mitchell, San Francisco. Copyright 1916 by V. Ferguson.)

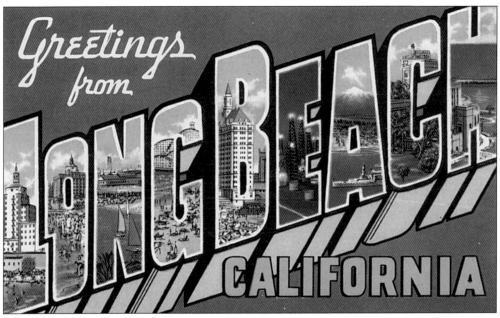

GREETINGS FROM LONG BEACH, CALIFORNIA. (P/P: Western Publishing & Novelty Co., Los Angeles. No. 91.)

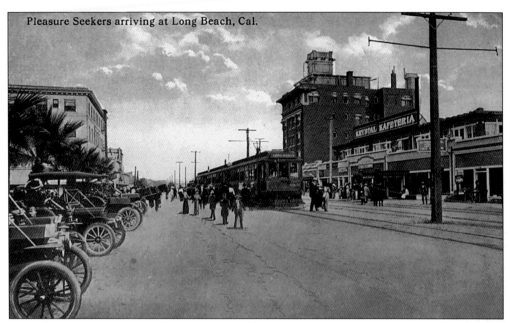

Pleasure Seekers arriving at Long Beach, Cal.

PLEASURE SEEKERS ARRIVING AT LONG BEACH, CALIFORNIA, BY PACIFIC ELECTRIC TRAIN FROM DOWNTOWN LOS ANGELES. (P/P: Carlin Post Card Co., Los Angeles. No. 1109.)

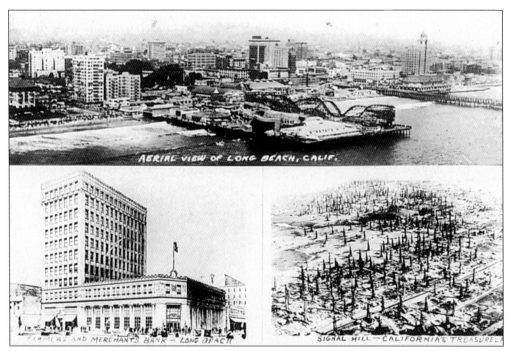

AERIAL VIEW OF LONG BEACH, CALIFORNIA; FARMERS AND MERCHANTS BANK, LONG BEACH; SIGNAL HILL, CALIFORNIA'S TREASURELAND. (P/P: Unknown.)

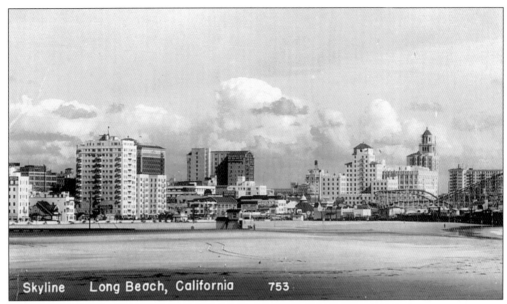

SKYLINE, LONG BEACH, CALIFORNIA. (P/P: Los Angeles Post Card Co., Los Angeles. No. 753.)

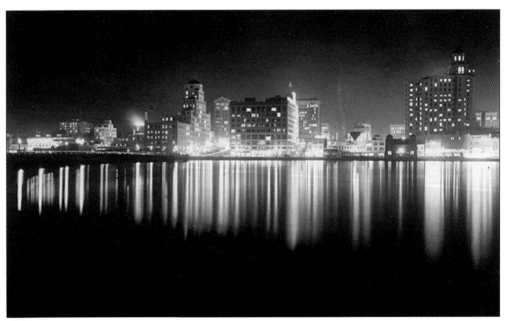

SKYLINE AT NIGHT, LONG BEACH, CALIFORNIA. (P/P: Hoffman Photo Service, No. 137.)

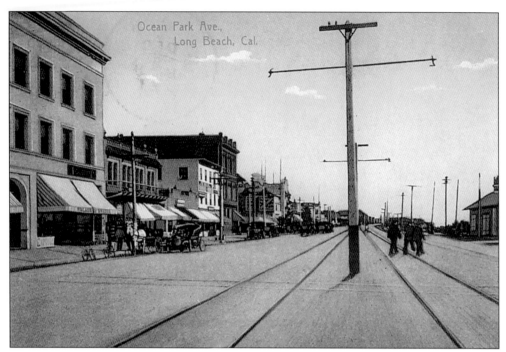

OCEAN PARK AVENUE, LONG BEACH, CALIFORNIA. The written message on back reads: "The other day we went to pick olives. Now we are curing them." (P/P: M. Rieder, Los Angeles. No. 9029. Made in Germany. Postmark: December 1908.)

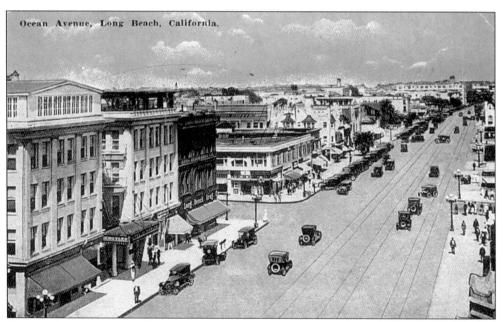

OCEAN AVENUE, LONG BEACH, CALIFORNIA. (P/P: California Post Card Co., Los Angeles. No. 25053N. Postmark: August 1925.)

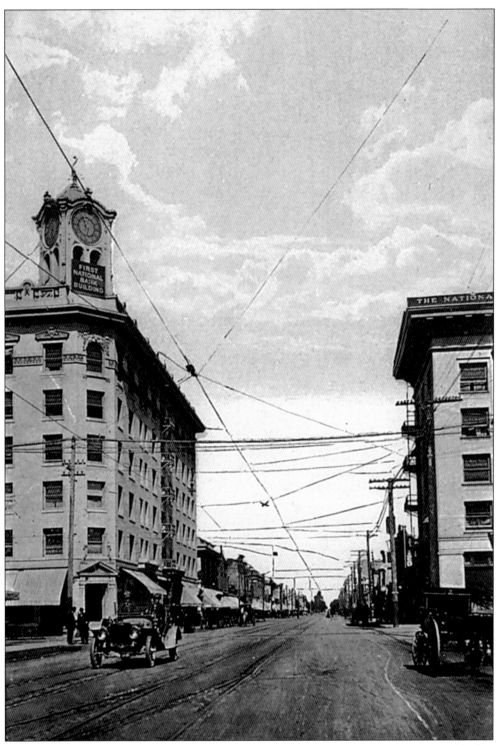

PINE AVENUE, LONG BEACH, CALIFORNIA. (P/P: The Los Angeles News Co., Los Angeles. No. M2076.)

14

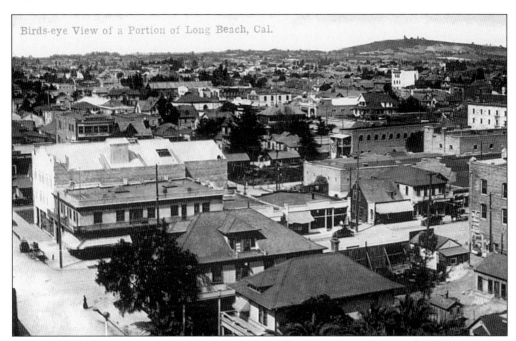

BIRDS-EYE VIEW OF A PORTION OF LONG BEACH, CALIFORNIA. (P/P: Van Ornum Colorprint Co., Los Angeles. No. 467.)

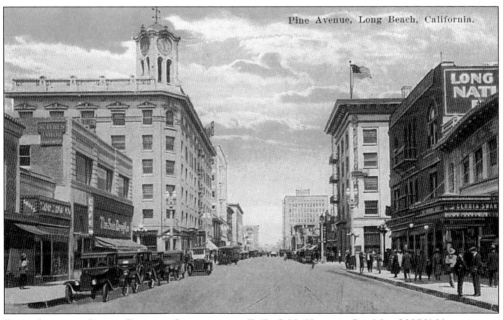

PINE AVENUE, LONG BEACH, CALIFORNIA. (P/P: S.H. Kress & Co. No. 28950N.)

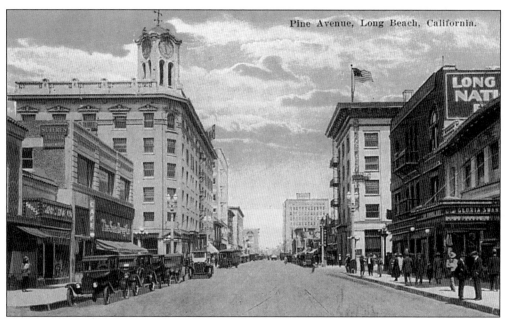

PINE AVENUE, LONG BEACH, CALIFORNIA. (P/P: Unknown. No. S1112. Postmark: June 1915.)

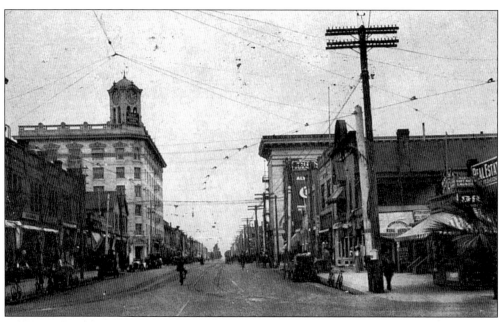

LOOKING EAST ON OCEAN AVENUE, LONG BEACH, CALIFORNIA. Text on the card reads: "Ocean Avenue, one of the main thoroughfares of Long Beach, extends the full length of the city along the ocean. Here are located many fine hotels and apartments. The ocean side of the boulevard, just east of the business area, is bordered by a beautiful park overlooking the palisades and beach." (P/P: Western Publishing & Novelty Co., Los Angeles. No. L15. Postmark: July 1944.)

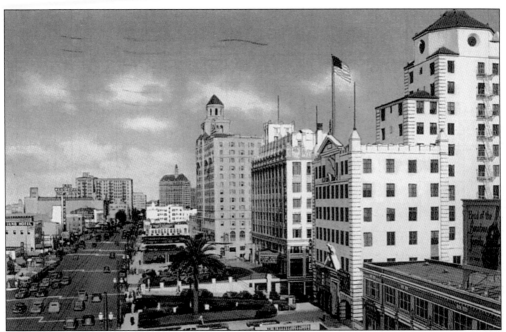

Looking West on Ocean Avenue, Showing Beach Front, Long Beach, California. (P/P: Tichnor Art Co., Los Angeles. No. T217. Postmark: September 1937.)

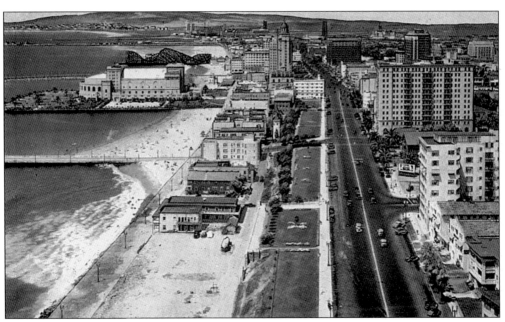

Ocean Avenue, Long Beach, California. The message on back, written to Kennebunkport, Maine, reads: "Had a wonderful trip out, through Salt Lake, Sacramento, Frisco. California has Florida beat a million miles in every way & one gets lots more for their money. We have a peachy apartment & we are really enjoying it." (P/P: M. Kashower Co., Los Angeles. No. 287. Postmark: October 1937.)

17

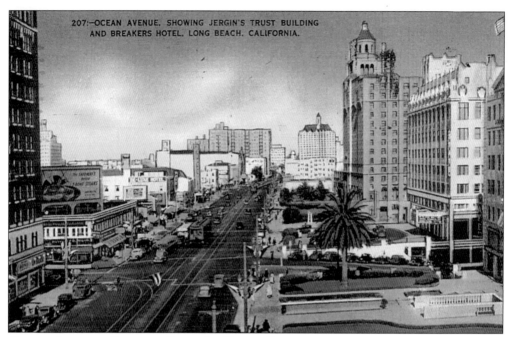

OCEAN AVENUE, SHOWING JERGIN'S TRUST BUILDING AND BREAKERS HOTEL, LONG BEACH, CALIFORNIA. The message on back reads: "Margaret and I went to LA Sunday—heard Aimie [Semple McPherson] so will send you some of her literature later. I don't think much of her. . ." (P/P: Gardner Thompson, Los Angeles. No. 207. Postmark: October 1941.)

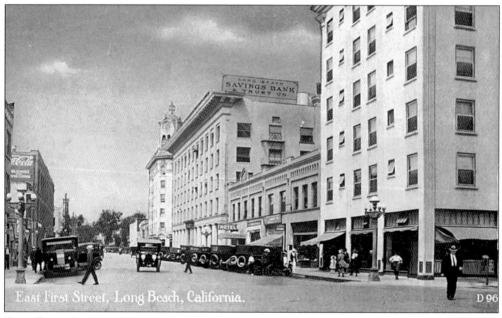

EAST FIRST STREET, LONG BEACH, CALIFORNIA. (P/P: Pacific Novelty Co., San Francisco & Los Angeles. No. D96.)

18

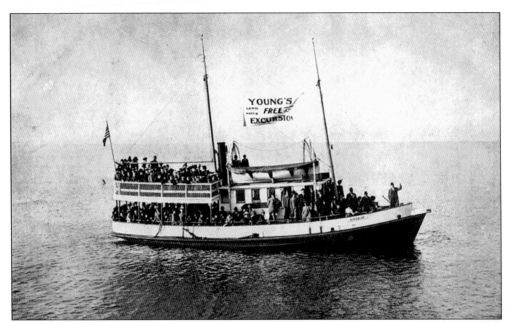

YOUNG'S FREE EXCURSION. "It is just as essential for you to take J.W. Young's Free Land and Water Excursion when in Long Beach, California, as it is to see Niagara Falls when in Buffalo." (P/P: J.W. Young Real Estate, Long Beach.)

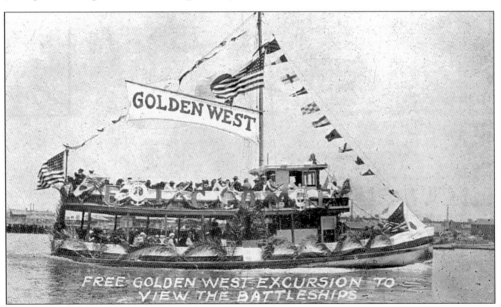

FREE GOLDEN WEST EXCURSION TO VIEW THE BATTLESHIPS. Text on the card reads: "See beautiful Long Beach, San Pedro Harbor, Battleships, Ship Yards, Dead Man's Island, Point Firman, Southern California Yacht Club, all by boat ride on the water. Save this card or send it to your friends. It will identify and entitle you to a beautiful excursion and country dinner at Signal Hill, the most wonderful oil field in the world. Hear James H. Knowles lecture on how he made money for his vast clientele of oil investors." (P/P: Golden West Boat, Knowles and Elliott, Lessees.)

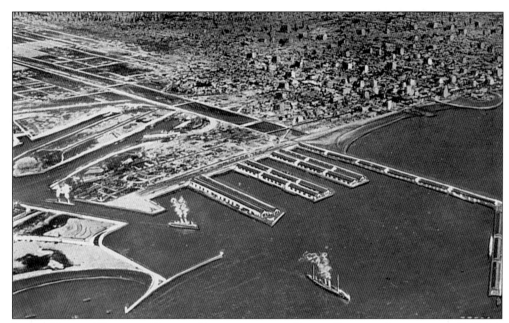

LONG BEACH HARBOR UNDER CONSTRUCTION, LONG BEACH, CALIFORNIA. (P/P: M. Kashower, Los Angeles, No. 208A.)

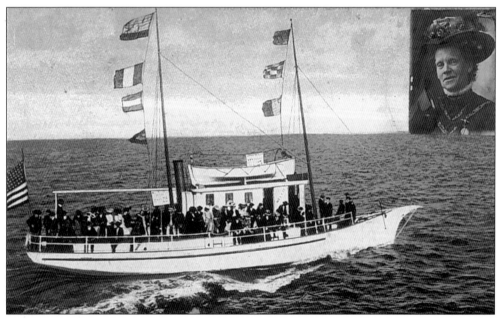

THE NELLE **LEAVING LONG BEACH FOR SAN PEDRO.** This card has a beach photo attached. Is it a man or a woman? (P/P: Newman Post Card Co., Los Angeles. No. 5187.)

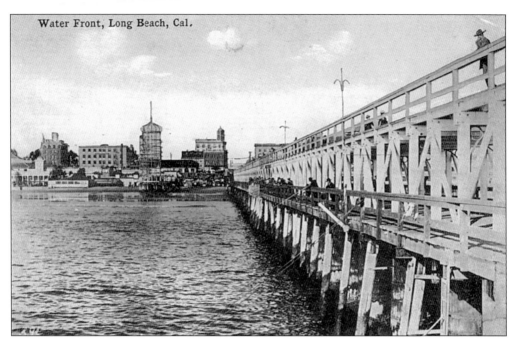

Water Front, Long Beach, Cal.

WATER FRONT, LONG BEACH, CALIFORNIA. (P/P: Western Publishing & Novelty Co. Los Angeles. No. 396.)

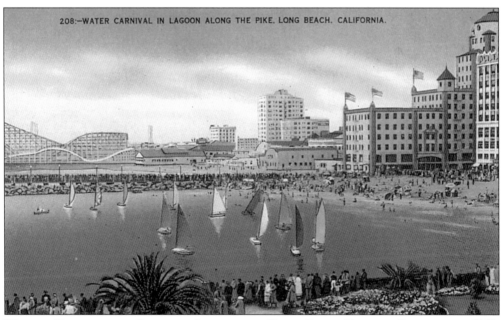

208:—WATER CARNIVAL IN LAGOON ALONG THE PIKE, LONG BEACH, CALIFORNIA.

WATER CARNIVAL IN LAGOON ALONG THE PIKE, LONG BEACH, CALIFORNIA. (P/P: Gardner Thompson, Los Angeles. No. 208.)

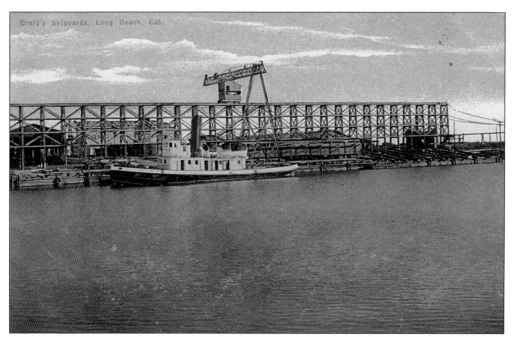

CRAIG'S SHIPYARDS, LONG BEACH, CALIFORNIA. These yards opened in 1906. (P/P: Los Angeles News Agency, Los Angeles. No. M2062.)

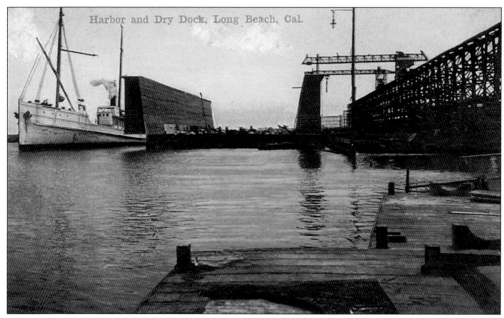

HARBOR AND DRY DOCK, LONG BEACH, CALIFORNIA. (P/P: Souvenir Publishing Co., Los Angeles & San Francisco. No. D64.)

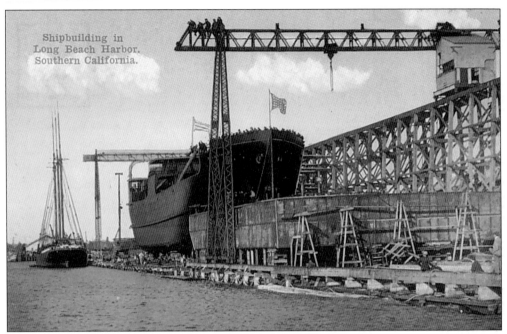

SHIP BUILDING IN LONG BEACH HARBOR, SOUTHERN CALIFORNIA. (P/P: Van Ornum Colorprint Co. Los Angeles. No. 473.)

UNITED STATES NAVY LANDING, LONG BEACH, CALIFORNIA. "Shore leave begins at Navy Landing in Long Beach, which is home port to a large part of the United States Fleet in the Pacific waters." (P/P: Longshaw Card Co., Los Angeles. No. 22.)

Navy Landing, Long Beach, California. (P/P: Tichnor Art Co., Los Angeles. No. T535.)

U.S. Battleships Anchored at Long Beach, California. (P/P: Gardner Thompson, Los Angeles. No. 200.)

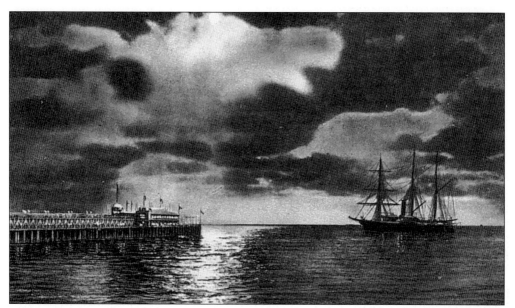

Moonlight Scene at Long Beach, California. (P/P: Western Publishing & Novelty Co., Los Angeles. No. L3. Postmark: June 1924.)

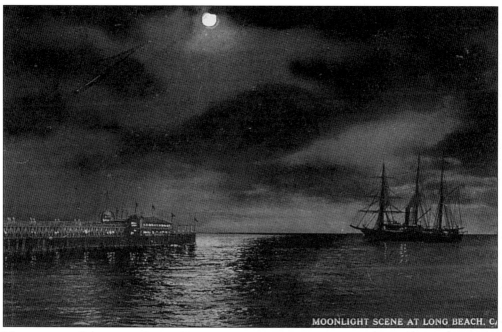

MOONLIGHT SCENE AT LONG BEACH, C

Moonlight Scene at Long Beach, California. (P/P: Newman Post Card Co., Los Angeles & San Francisco. No. D19.)

[BEACH PHOTOGRAPHER PHOTO] A note added June 11, 1982, reads: "This lady now lives in Youngstown, Arizona. Just as nice as she is pretty." (P/P: Seaside Studio, J.C. Hayden Prop., Long Beach. Dated January 24, 1920.)

Two
THE BEACH AND AMUSEMENT PARK

LONG BEACH, CALIFORNIA. (P/P: M. Rieder, Los Angeles. No. 1524. Made in Germany. Undivided back. Postmark: July 1906.)

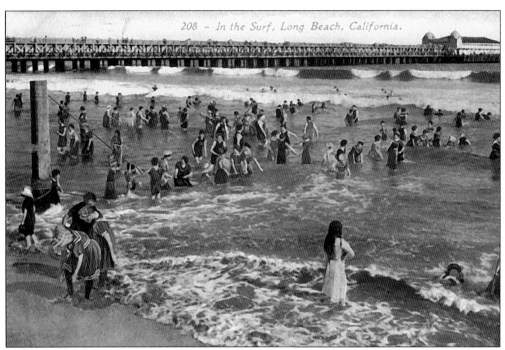

IN THE SURF, LONG BEACH, CALIFORNIA. (P/P: Edward H. Mitchell, San Francisco. No. 208. Postmark: May 1912.)

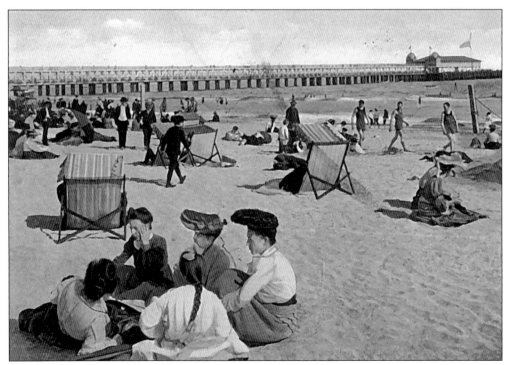

SCENE AT LONG BEACH, CALIFORNIA. (P/P: M. Rieder, Los Angeles & Leipzig. No. 3317. Postmark: July 1908.)

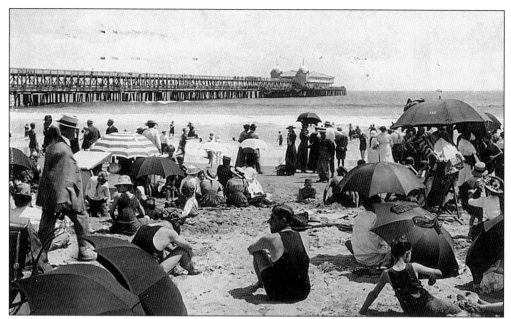

BEACH SCENE, LONG BEACH, CALIFORNIA. (P/P: Western Publishing & Novelty Co., Los Angeles. No. 324. Postmark: October 1920.)

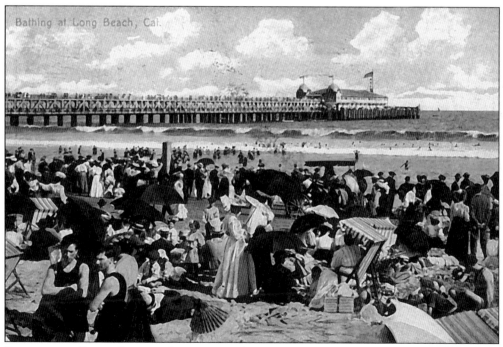

BATHING AT LONG BEACH, CALIFORNIA. (P/P: Newman Post Card Co., Los Angeles. No. 6076. Made in Germany. Postmark: July 1908.

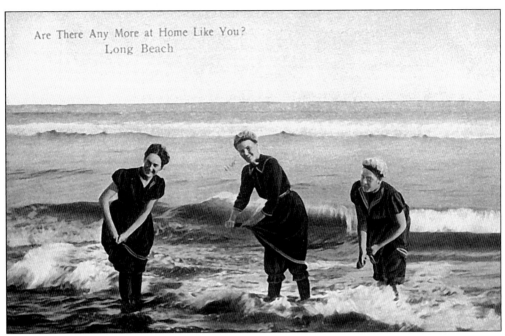

ARE THERE ANY MORE AT HOME LIKE YOU? LONG BEACH. (P/P: M. Rieder, Los Angeles. No. 3144. Made in Germany.)

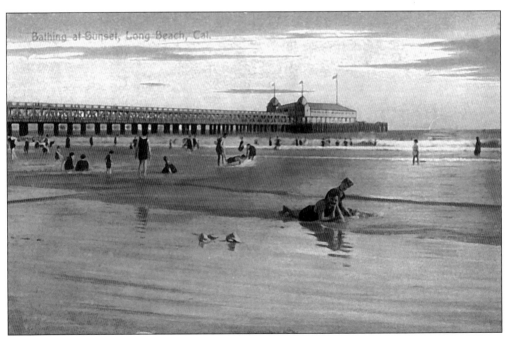

BATHING AT SUNSET, LONG BEACH, CALIFORNIA. (P/P: Newman Post Card Co., Los Angeles. No. D37. Made in Germany.)

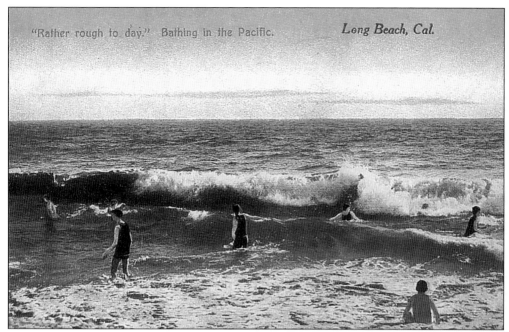

"RATHER ROUGH TO DAY." BATHING IN THE PACIFIC, LONG BEACH, CALIFORNIA. (P/P: Newman Post Card Co., Los Angeles. No. AA1.)

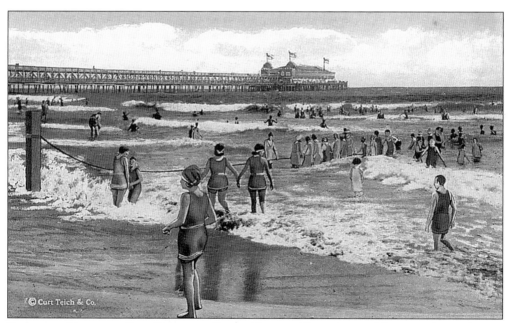

PLEASURE PIER AND SUN PAVILION, LONG BEACH, CALIFORNIA. The rope gives assistance to those who do not know how to swim. (P/P: Western Publishing & Novelty, Los Angeles. No. L29.)

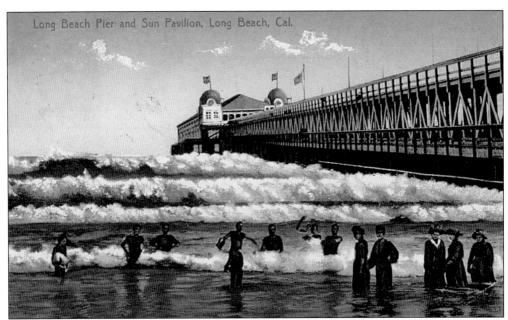

Long Beach Pier and Sun Pavilion, Long Beach, Cal.

LONG BEACH PIER AND SUN PAVILION, LONG BEACH, CALIFORNIA. "The Sun Palace was completed and dedicated April 6, 1905. The Marine Band played and an evening dance was attended by about 3,000 guests." (*Long Beach, the Golden Shore, A History of the City and Port,* Pioneer Press, Houston, TX, 1988, p.52.) (P/P: M. Rieder, Los Angeles. No. 9391. Made in Germany. Postmark: 1909.)

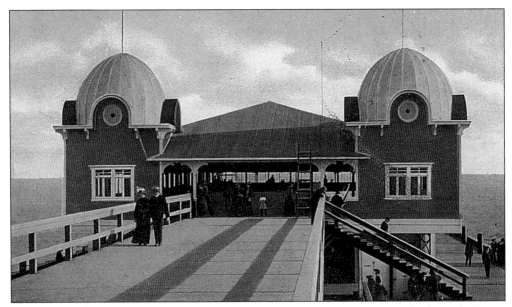

SUN PAVILION, LONG BEACH, CALIFORNIA. The message written on back reads: "Ripe olives—um! Figs no more thank you. Old ocean has changed somewhat no more bathing in front of bathhouse but at rear of the Virginia [Hotel]. Some cruiser must have spilt a vat of oil last night for the 'surf' was horribly greasy this am." (P/P: M. Rieder, Los Angeles. No. 3271. Made in Germany. Postmark: July 1908.)

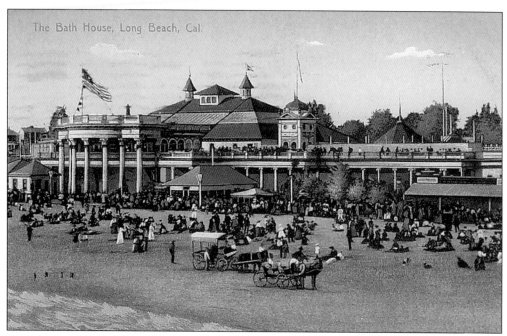

THE BATHHOUSE, LONG BEACH, CALIFORNIA. (P/P: M. Rieder, Los Angeles. No. 9031. Made in Germany. Postmark: February 1911.)

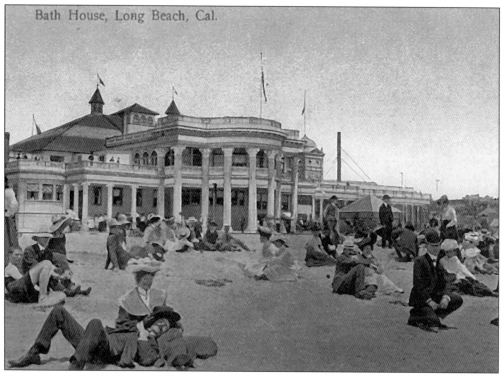

BATHHOUSE, LONG BEACH, CALIFORNIA. (P/P: M. Rieder, Los Angeles. No. 3049. Made in Germany.)

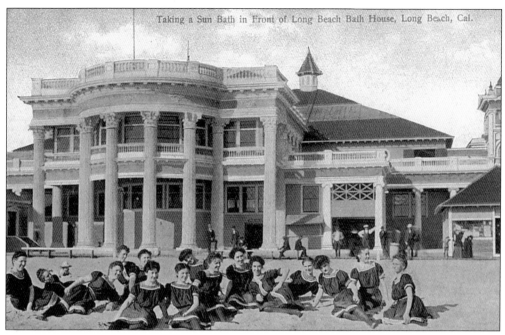

TAKING A SUN BATH IN FRONT OF LONG BEACH BATHHOUSE, LONG BEACH, CALIFORNIA. (P/P: M. Rieder, Los Angeles & Leipzig. No. 3098.)

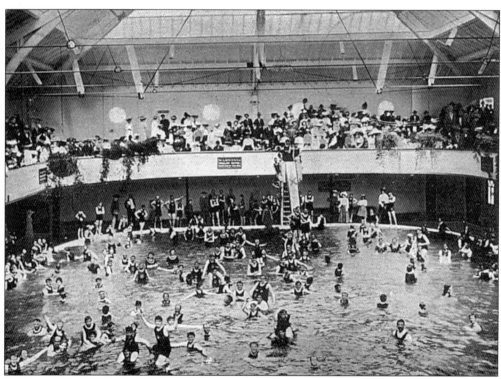

INTERIOR OF PLUNGE, LONG BEACH, CALIFORNIA, NEW YEAR'S DAY. (P/P: M. Rieder, Los Angeles. No. 3326. Made in Germany. Postmark: June 1907.)

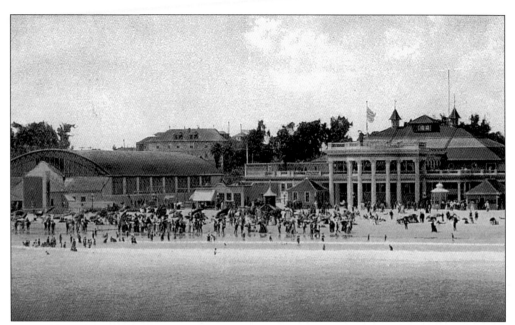

LONG BEACH FROM THE PIER, SHOWING BATHHOUSE AND SKATING RINK. (P/P: M. Rieder, Los Angeles. No. 3759. Made in Germany.)

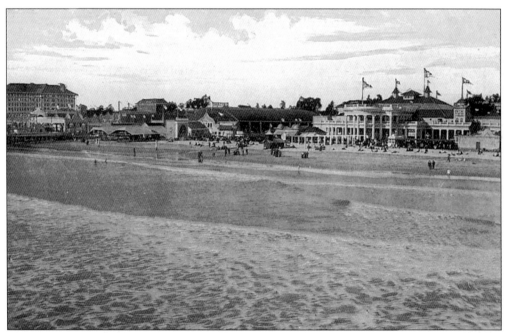

VIEW OF STRAND, LONG BEACH, CALIFORNIA, SEEN ON TILTON'S 100-MILE TROLLEY TRIP. Text on the card reads: "Here is what it would cost you to visit the points seen on Tilton's trip. Pasadena and Ostrich Farm, $.50; San Gabriel Mission and orange groves, $.55; Long Beach, $.50; Alamitos Bay and Naples, $.20; Total individual cost, $1.75. But all for $1.00 on Tilton's cars, with a reserved chair free and a competent guide." (P/P: Newman Post Card Co. Los Angeles & San Francisco.)

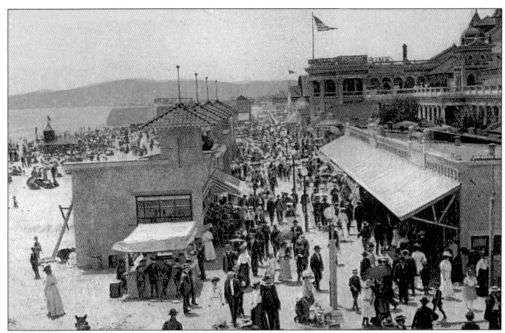

BATHHOUSES AND SURF SCENE. (P/P: Paul C. Hoeber, NY and Kirchheim, Germany. No. 4083.)

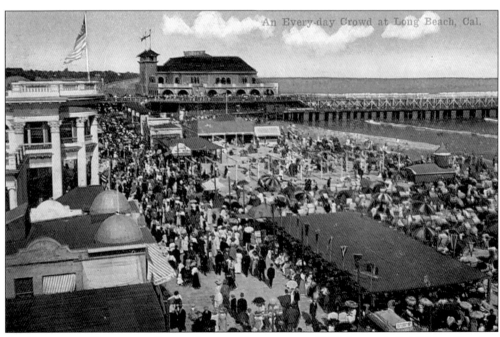

AN EVERYDAY CROWD AT LONG BEACH, CALIFORNIA. (P/P: Souvenir Publishing Co., Los Angeles & San Francisco. No. 6901. Postmark: July 1915.)

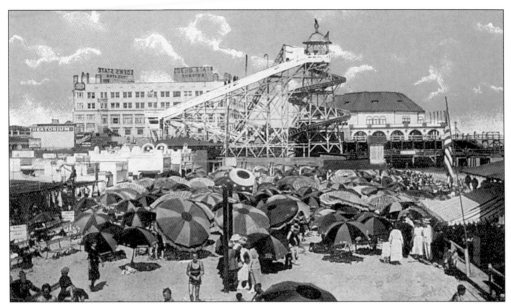

An Everyday Beach Scene, Long Beach, California. (P/P: California Post Card Co., Los Angeles. No. 25056N.)

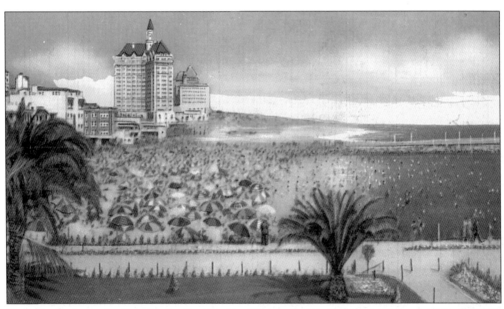

Bathing in the Lagoon, Looking East from Auditorium, Long Beach, California. Text on the card reads: "Long Beach with its colorful parks, modern buildings, and its dazzling shore line to which visitors flock, points with pride to its place as fifth largest city in California." (P/P: Longshaw Card Co., Los Angeles. No. 271. Postmark: November 1948.)

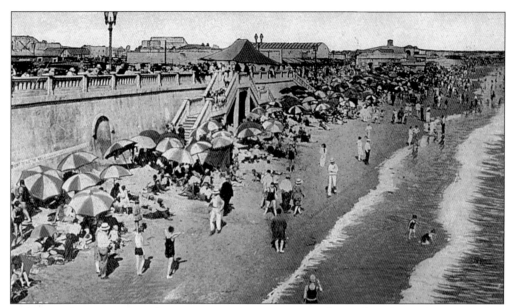

BELMONT BEACH, LONG BEACH, CALIFORNIA. Text on the card reads: "Belmont Beach is fortunately situated and has been endowed by nature with many natural advantages which cannot be found elsewhere on the Pacific Coast. We have miles of glistening white sand, gradual sloping beach and a wonderful surf which affords great pleasure to the bather." (P/P: M. Kashower, Los Angeles. No. 31488.)

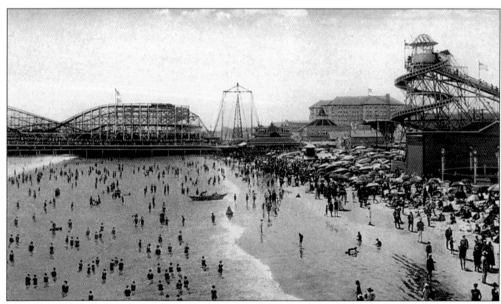

A TYPICAL BATHING SCENE AT LONG BEACH, CALIFORNIA. (Western Publishing & Novelty Co., Los Angeles. No R77359.)

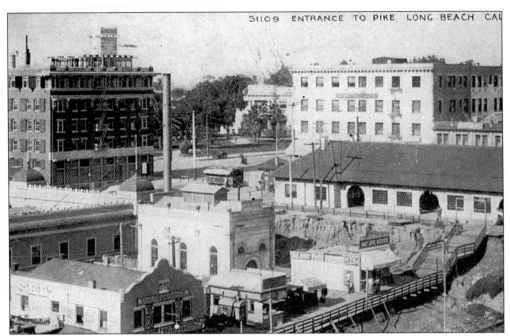

ENTRANCE TO PIKE, LONG BEACH, CALIFORNIA. The Pike was also known as the "Walk of a Thousand Lights." (P/P: Unknown. No. S1109. Postmark: July 1911.)

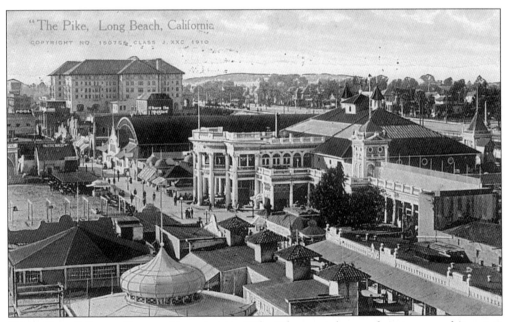

"THE PIKE," LONG BEACH, CALIFORNIA. "The Pike was a happy place to go, and it was so affordable and so easy to reach that many, many people did." (Loretta Bryuner, *Shades of the Past*, Historical Society of Long Beach, 1995, p. 9.) (P/P: Carlin Post Card Co., Los Angeles. Copyright no. 150755 Class JXXC, 1910. Coppergraphs were made in Los Angeles by the Phillips Printing Co., Postmark: December 1913.)

39

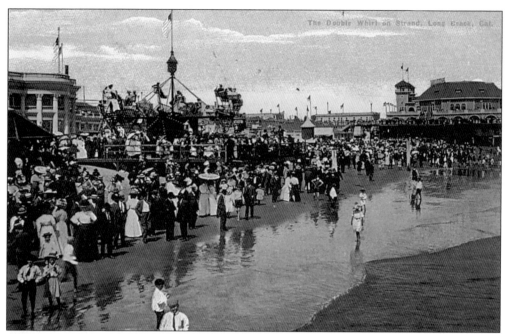

THE DOUBLE WHIRL ON STRAND, LONG BEACH, CALIFORNIA. This card was written in Merced, California, "while changing [train] cars for Yosemite Valley." (P/P: Los Angeles Times News Co., Los Angeles. No. M2073. Postmark: June 1911.)

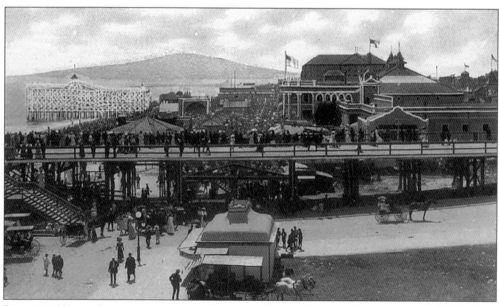

LOOKING WEST, SCENES ALONG THE STRAND, LONG BEACH, CALIFORNIA. (P/P: Benham Co., Los Angeles. No. 2308.)

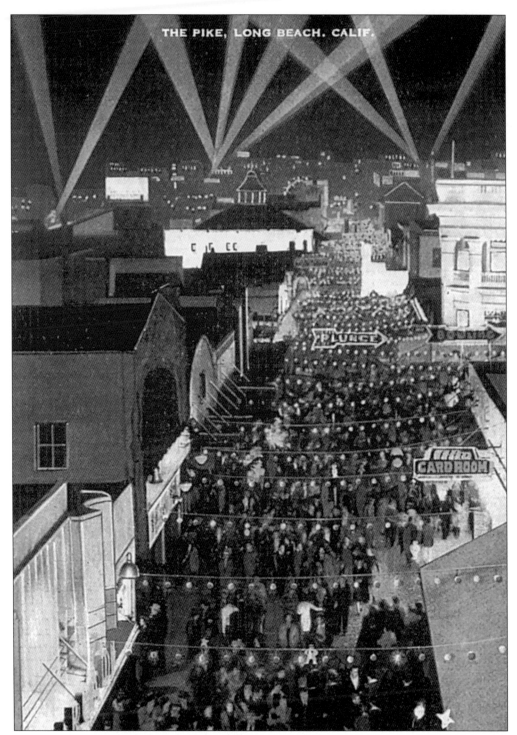

THE PIKE, LONG BEACH, CALIFORNIA, BY NIGHT. Text on the card reads: "The Pike is the 'Play Way' of Long Beach. Adjacent to the beach it offers a variety of thrilling 'rides' and other exciting amusements."(P/P: Drown News Agency, Long Beach, California. No. 30559.)

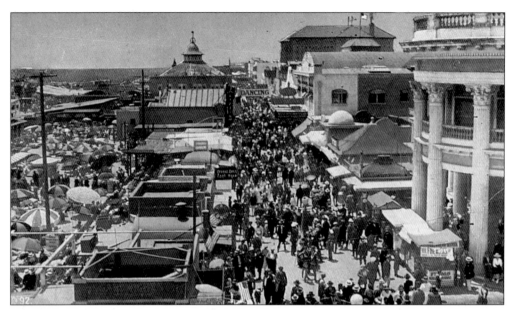

THE PIKE, LONG BEACH, CALIFORNIA. The Dodg'em, the second bump ride established on the Pike, was built in the early '20s, and was still in use in 1948. (P/P: Pacific Novelty Co., San Francisco & Los Angeles. No. D92. Postmark: October 1923.)

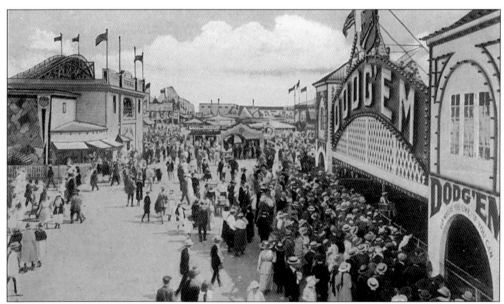

SILVER SPRAY PIER, LONG BEACH, CALIFORNIA. (P/P: M. Kashower, Los Angeles. No. 226.)

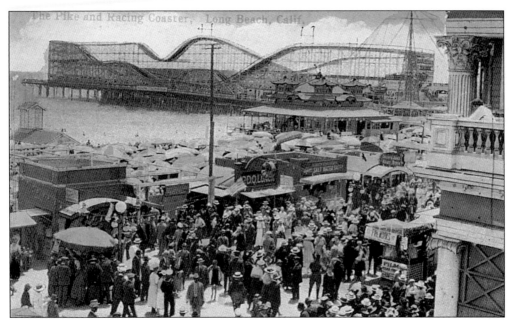

THE PIKE AND RACING COASTER, LONG BEACH, CALIFORNIA. The first roller coaster was built in June 1907. An ad in a local paper called it "Delightful-Breezy-Exciting ride—High over the ocean—Beautifully illuminated at night—Perfectly safe—Bring the children." (*The Pike on the Sand*, Historical Society of Long Beach, 1982–3, p. 17) (P/P: M. Kashower, Los Angeles. No. 44. Postmark: August 1922.)

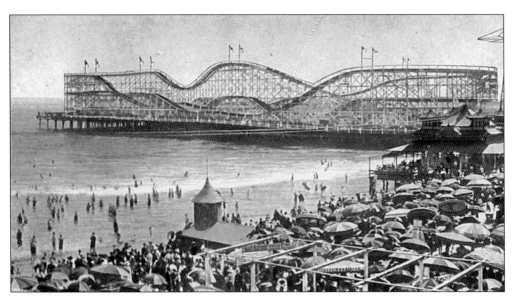

JACK RABBIT RACER, LONG BEACH, CALIFORNIA. The original, smaller coaster was torn down in March 1914, and on May 1, 1915, the Jack Rabbit Racer opened and was in use until 1929. (P/P: Pacific Novelty Co., San Francisco. No. D87.)

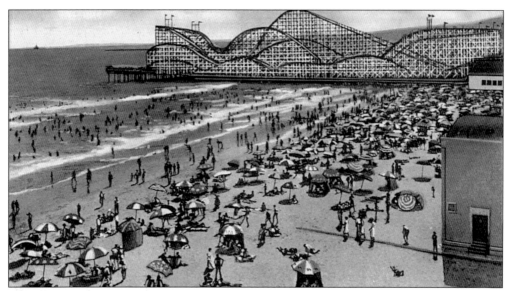

THE CYCLONE RACER AND BEACH CROWDS, LONG BEACH, CALIFORNIA. The Cyclone Racer opened in 1930, and was used for 38 years. The big dip dropped 85 feet. It was the only two-track roller coaster in the U.S., and the final day of use was September 15, 1968. (P/P: Western Publishing & Novelty Co., Los Angeles & San Francisco. No. D41.)

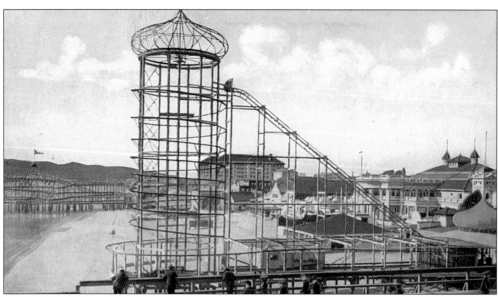

THE PIKE, AS SEEN FROM THE PIER, LONG BEACH, CALIFORNIA. (P/P: Newman Postcard Co., Los Angeles & San Francisco. No D41.)

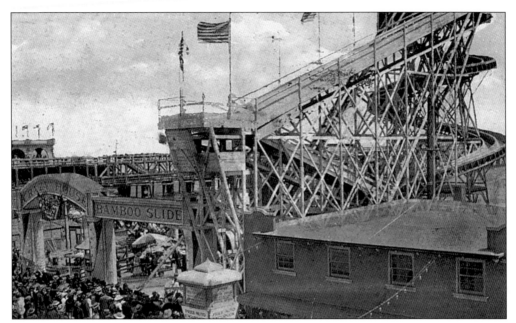

BAMBOO SLIDE, LONG BEACH, CALIFORNIA. (P/P: M. Kashower, Los Angeles. No. 43. Postmark: August 1925.)

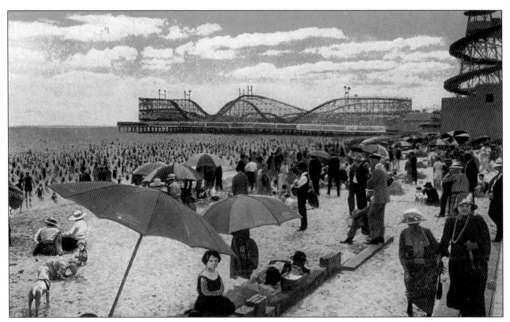

WATCHING THE BATHERS, LONG BEACH, CALIFORNIA. (P/P: Western Publishing & Novelty Co., Los Angeles. No. L51.)

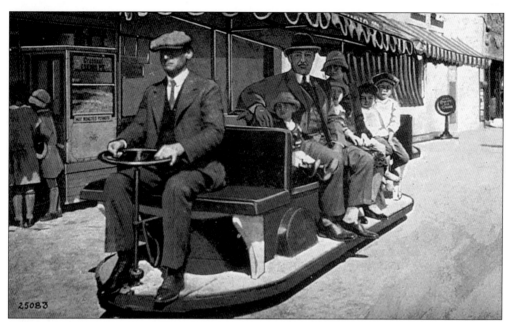

"Tram" on the Pike, Long Beach, California. The Free Tram went along the beachfront and later around the Rainbow Pier. (P/P: M. Kashower, Los Angeles. No. 211A.)

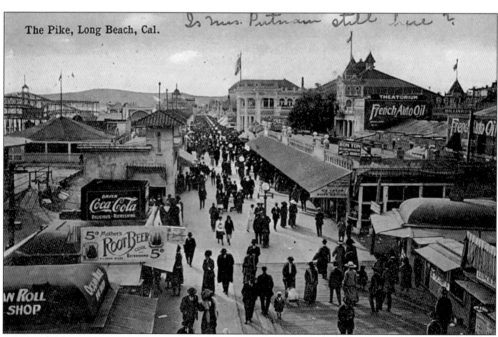

The Pike, Long Beach, California. The message written on back reads: ". . . Sold the house a week ago today. . . So Dad and I beat it to this place over SP (Southern Pacific) Tuesday night. . . We think we will stay here at 'The Earl' all winter—lovely apartment house right on the water. . ." (P/P: Western Publishing & Novelty Co., Los Angeles. Postmark: October 1913.)

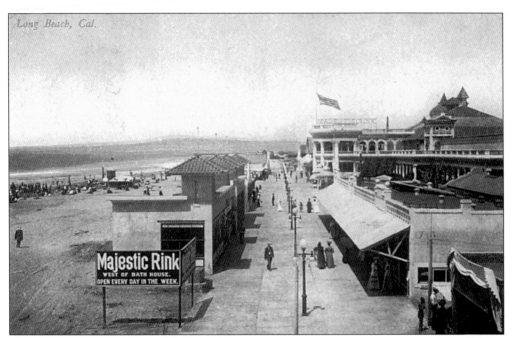

LONG BEACH, CALIFORNIA. THE SIGN ADVERTISES THE MAJESTIC SKATING RINK JUST BEYOND THE BATH HOUSE. The original boardwalk was replaced with cement in February 1906. (P/P: Posin & Co., Philadelphia & New York. No. 855. Made in Germany.)

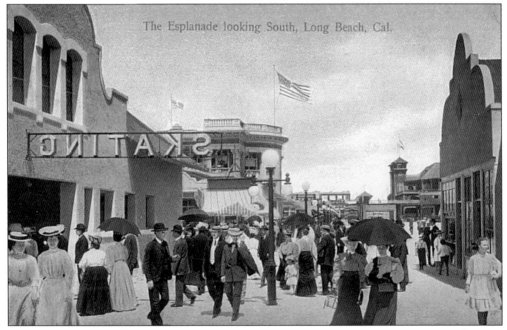

THE ESPLANADE LOOKING SOUTH, LONG BEACH, CALIFORNIA. (P/P: M. Rieder, Los Angeles. No. 3757. Made in Germany.)

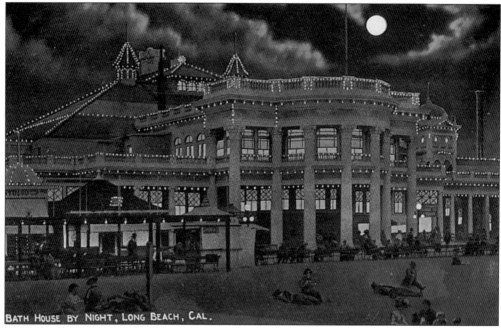

BATH HOUSE BY NIGHT, LONG BEACH, CALIFORNIA. The message written on back reads: "This faces the sea and you can see how the people are lying in the sand. It is nothing to see women lying down in the sand. I think it looks horrid to see them & so many men walking around all the time." (P/P: Western Publishing & Novelty Co., Los Angeles.)

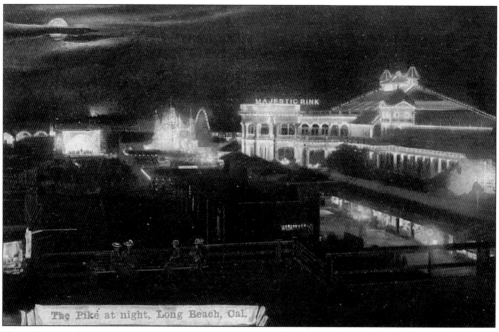

THE PIKE AT NIGHT, LONG BEACH, CALIFORNIA. (P/P: Newman Postcard Co., Los Angeles & San Francisco. No. D10.)

Three
AUDITORIUM, PIER, AND BAND SHELL

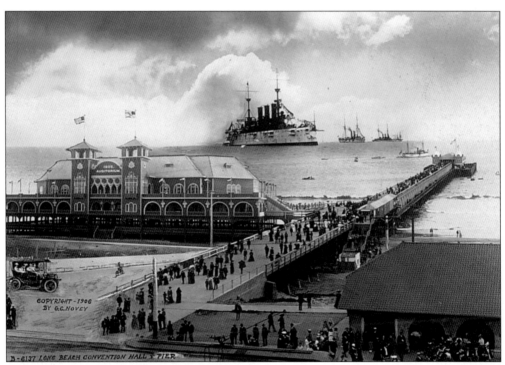

LONG BEACH CONVENTION HALL & PIER. This non-postcard was purchased in Long Beach in 1907–08 by Belva Snively Heckman, grandmother of the author. (P/P: Hovey Prints of Southern California, Long Beach. Copyright 1906 by G.C. Hovey. No. B6137.)

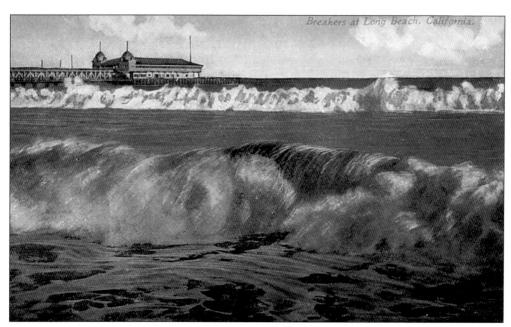

BREAKERS AT LONG BEACH, CAL. (P/P: Van Ornum Colorprint Co., Los Angeles. No. 850. Handwritten date: December 28, 1918.)

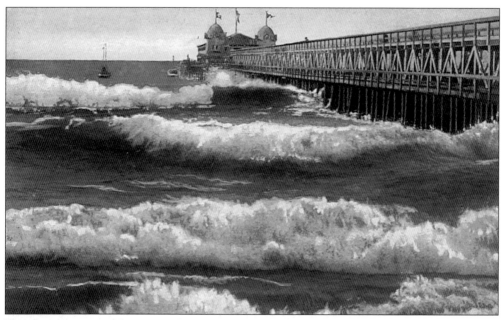

THE BREAKERS AND PLEASURE PIER, LONG BEACH, CAL. (P/P: Van Ornum Colorprint Co., Los Angeles. No. 424.)

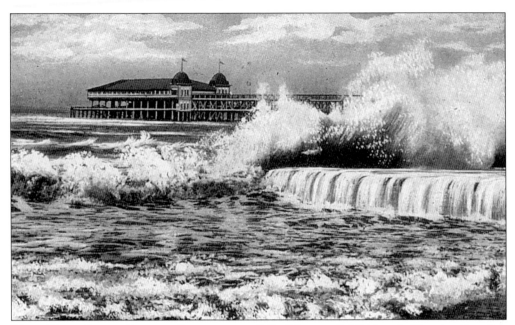

HIGH TIDE, LONG BEACH, CALIFORNIA. (P/P: Western Publishing & Novelty Co., Los Angeles. No. L55.)

HIGH TIDE, LONG BEACH, CALIFORNIA. (P/P: M. Kashower, Los Angeles. No. 282.)

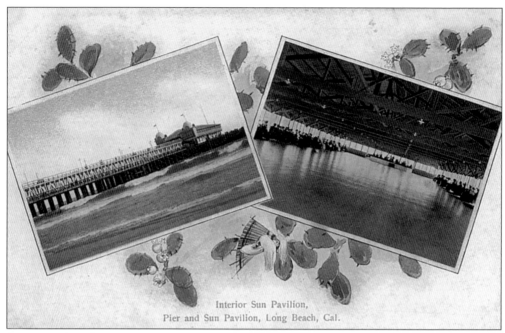

INTERIOR SUN PAVILION, PIER, AND SUN PAVILION, LONG BEACH, CALIFORNIA. (P/P: M. Rieder, Los Angeles. No. 3306. Made in Germany. Undivided back.)

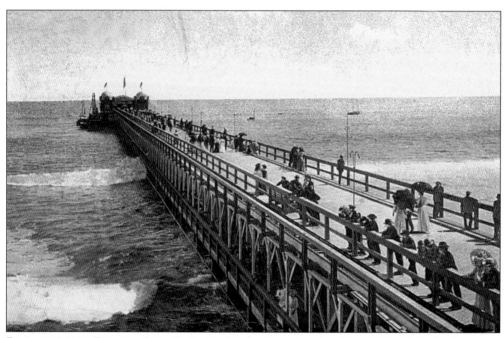

PIER AT LONG BEACH, CAL. (P/P: M. Rieder, Los Angeles. No. 3835. Made in Germany. Postmark: September 1908.)

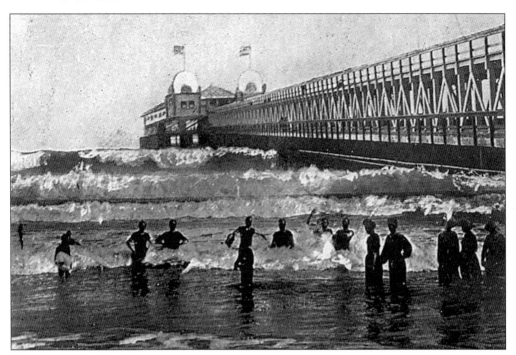

THE PIER AND SUN PAVILION, LONG BEACH, CALIFORNIA. (P/P: M. Rieder, Los Angeles. No. 3835. Undivided back.)

LONG BEACH FROM THE PIER. (P/P: Los Angeles Times News Co., Los Angeles. No. 25043.)

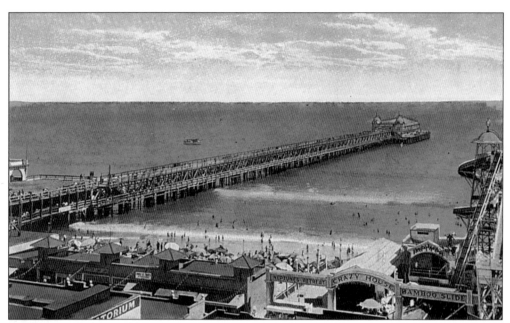

THE PIER, LONG BEACH, CALIFORNIA. (P/P: California Postcard Co., Los Angeles. No. 25043.)

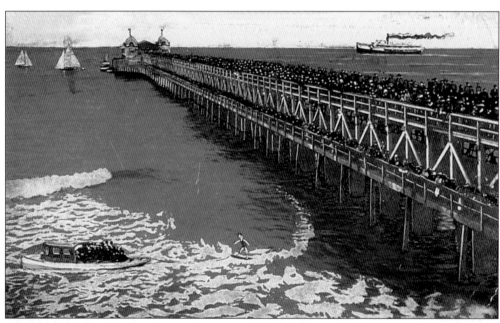

VIEWING WATER SPORTS FROM PLEASURE PIER, LONG BEACH, CALIFORNIA. (P/P: Van Ornum Colorprint Co., Los Angeles. No. 497. Postmark: September 1919.)

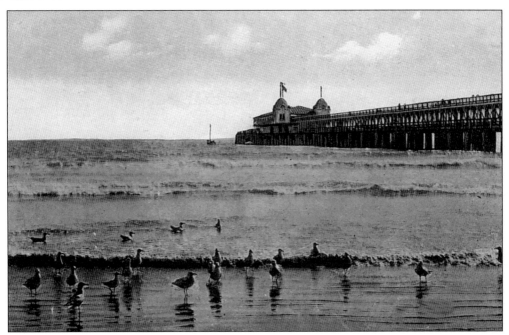

SEA GULLS AT LONG BEACH PIER, CALIFORNIA. (P/P: Western Publishing & Novelty Co., Los Angeles. No. 404.)

FRIDAY, **LONG BEACH, CALIFORNIA.** (P/P: M. Kashower, Los Angeles. No. 212.)

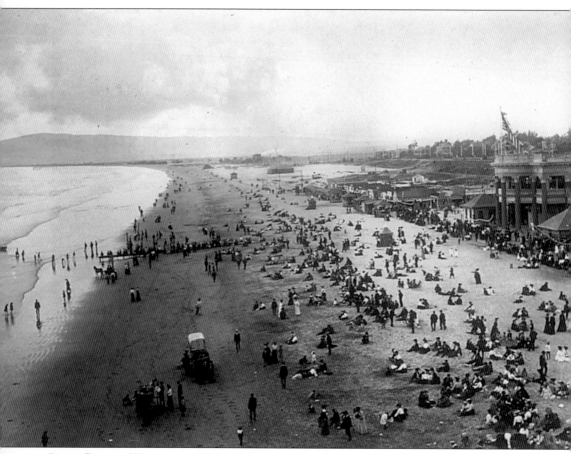

LONG BEACH, WEST FROM PIER. This non-postcard was purchased in Long Beach in 1907–08 by Belva Snively Heckman, grandmother of the author. (P/P: Hovey's Studio, Long Beach, Cal. Copyright by G.C. Hovey, 1905. No. 6128.)

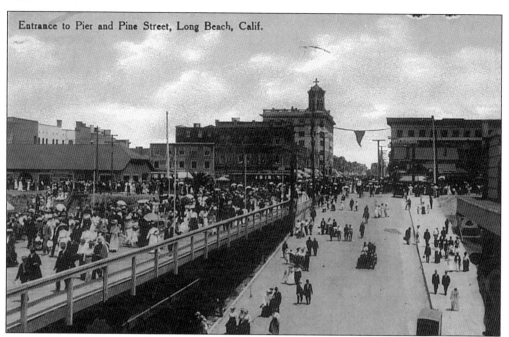

Entrance to Pier and Pine Street, Long Beach, Calif.

ENTRANCE TO PIER AND PINE STREET, LONG BEACH, CALIFORNIA. (P/P: Benham Co., Los Angeles. No. A3653. Postmark: August 1911.)

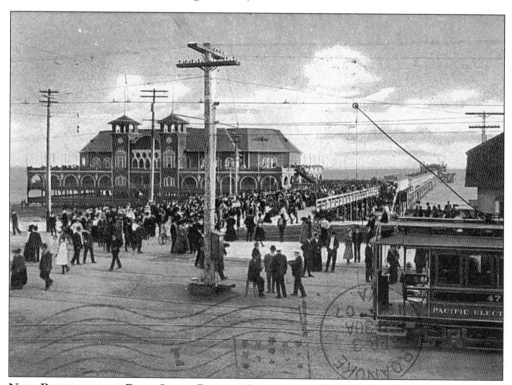

NEW PAVILION AND PIER, LONG BEACH, CALIFORNIA. (P/P: M. Rieder, Los Angeles. No. 3526. Made in Germany. Postmark: January 1907.)

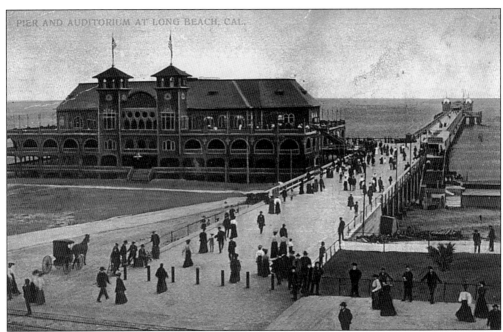

PIER AND AUDITORIUM AT LONG BEACH, CALIFORNIA. (P/P: Oscar Newman, Los Angeles. No. 51019. Postmark: August 1906.)

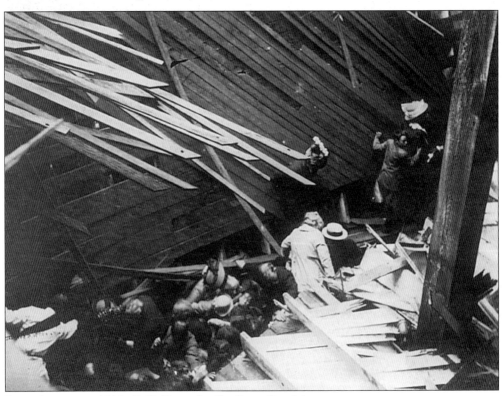

PIER COLLAPSE, 1913. (P/P: Burro Studio, Long Beach.)

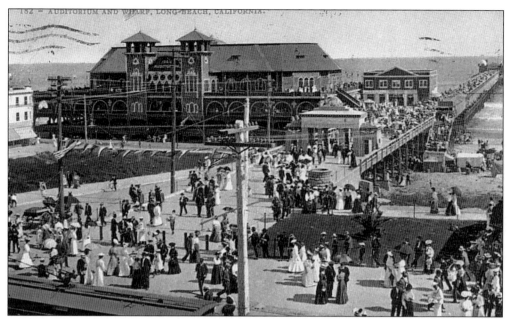

AUDITORIUM AND WHARF, LONG BEACH, CALIFORNIA. (P/P: Edward H. Mitchell, San Francisco. No. 182. Postmark: October 1907.)

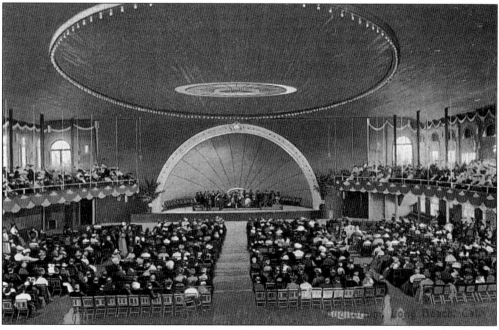

AUDITORIUM, LONG BEACH, CALIFORNIA. The handwritten note on the card reads: "Where we sang yesterday. Went there by trolley. Two private cars with lovely sofas, etc. Then back to Los Angeles to sleep, after the evening show. We are on the train for Bakerfield. Got up at six and we have slept on the train a good deal. Are going over sandy desert again with great mountains dropped down everywhere in rows and set down singly. . . ." (P/P: M. Rieder, Los Angeles & Dresden. No. 9033.)

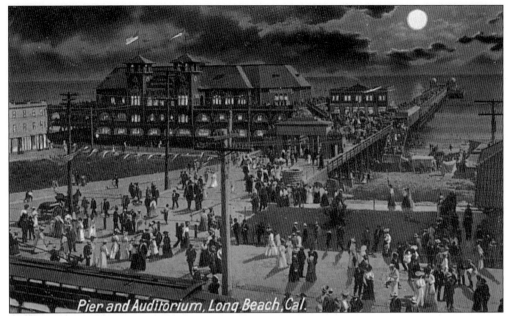

PIER AND AUDITORIUM, LONG BEACH, CALIFORNIA. (P/P: Newman Postcard Co., Los Angeles. No. D13. Made in Germany. Postmark: January 1910.)

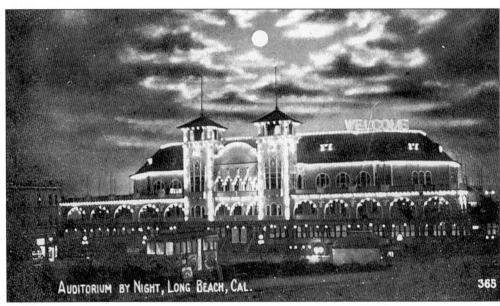

AUDITORIUM BY NIGHT, LONG BEACH, CALIFORNIA. Written on the back is: "This is the building that broke down when all the people were killed, while having a picnic." It became known as the Empire Day tragedy. On May 25, 1913, a large crowd had gathered outside the full auditorium, and they began stamping their feet in time to the music inside. At 11:35 a.m., the Pine Avenue Pier collapsed, and 350 people fell down through the lower level and onto the sand below. Thirty-six people died that day, and the death toll eventually reached 50. The pier was replaced and continued in use until 1932, when the Rainbow Pier was built. (P/P: Western Publishing & Novelty Co., Los Angeles. No. 365.)

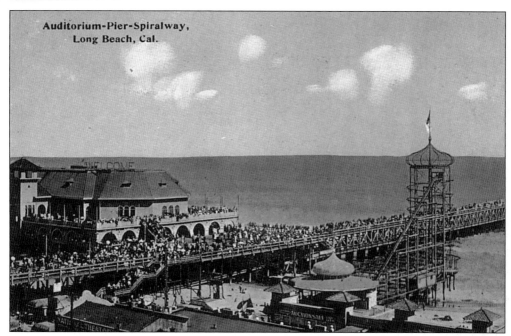

AUDITORIUM-PIER-SPIRALWAY, LONG BEACH, CALIFORNIA. Bisby's Airship was also known officially as the Spiral Way, but most people called it the "Gondola Ride." (P/P: Western Publishing & Novelty Co., Los Angeles.)

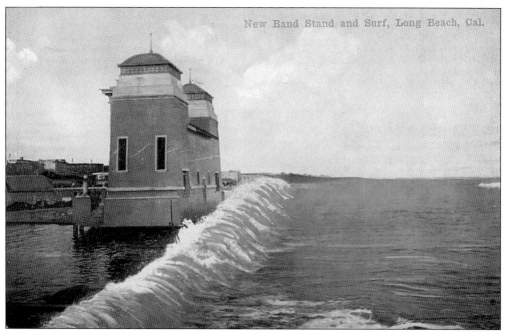

NEW BAND STAND AND SURF, LONG BEACH, CALIFORNIA. (P/P: Souvenir Publishing Co., Los Angeles & San Francisco. No. D58. Postmark: March 1913.)

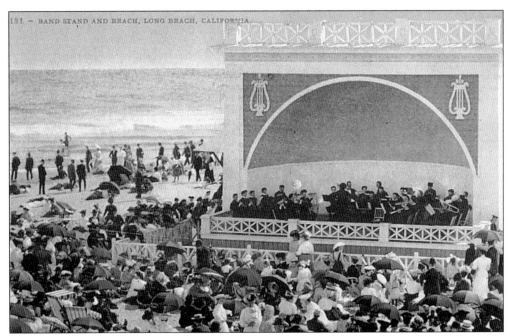

BAND STAND AND BEACH, LONG BEACH, CALIFORNIA. (P/P: Edward H. Mitchell, San Francisco. No. 181.)

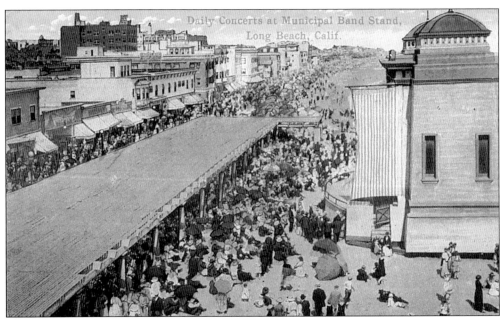

DAILY CONCERTS AT MUNICIPAL BAND STAND, LONG BEACH, CALIFORNIA. (P/P: M. Kashower, Los Angeles. No. 1080240.)

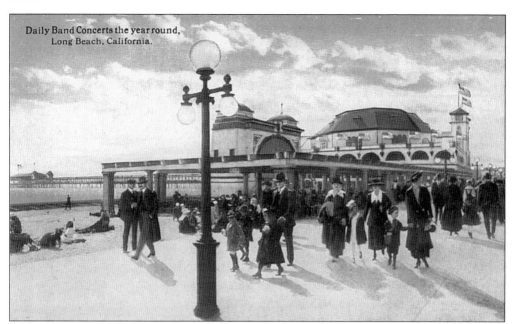

DAILY BAND CONCERTS THE YEAR AROUND, LONG BEACH, CAL. (P/P: Julius J. Hecht, Los Angeles. No. L27.)

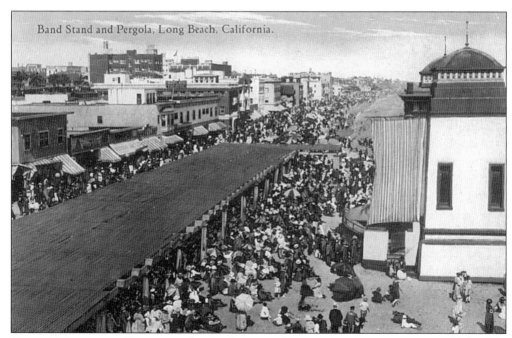

BAND STAND AND PERGOLA, LONG BEACH, CALIFORNIA. (P/P: Western Publishing & Novelty, Co., Los Angeles. No. L41.)

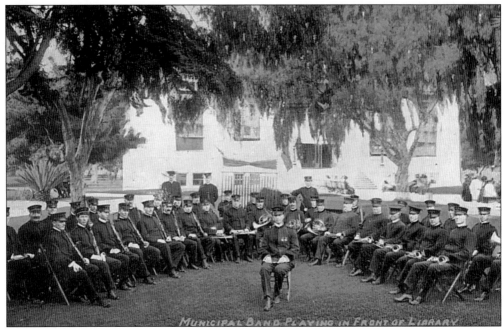

MUNICIPAL BAND PLAYING IN FRONT OF LIBRARY, LONG BEACH, CALIFORNIA. This was the first city-supported, year–round municipal band in the country. (P/P: Souvenir Publishing Co., Los Angeles & San Francisco. No. D63. Postmark: February 1916.)

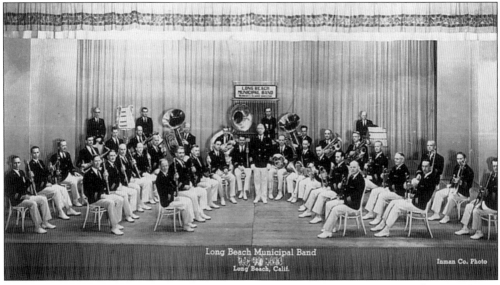

LONG BEACH MUNICIPAL BAND, LONG BEACH, CALIFORNIA. (P/P: Inman Photo Co.)

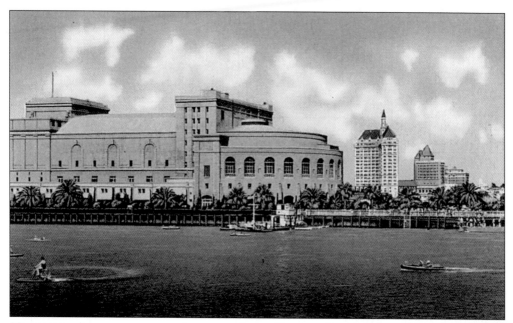

MUNICIPAL AUDITORIUM AND LAGOON, LONG BEACH, CALIFORNIA. Built in 1932 for $3 million, the Municipal Auditorium has an 8-acre marine park and a 32-acre still-water lagoon. (P/P: Tichnor Art Co., Los Angeles. No. T533.)

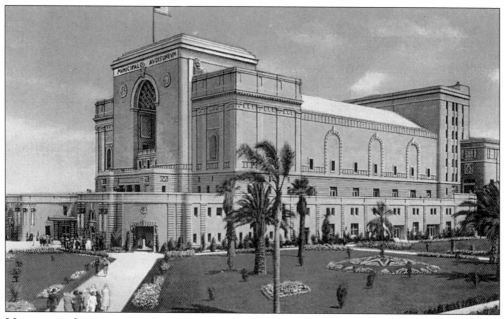

MUNICIPAL AUDITORIUM, LONG BEACH, CALIFORNIA. (P/P: Western Publishing & Novelty Co., Los Angeles. No. L88.)

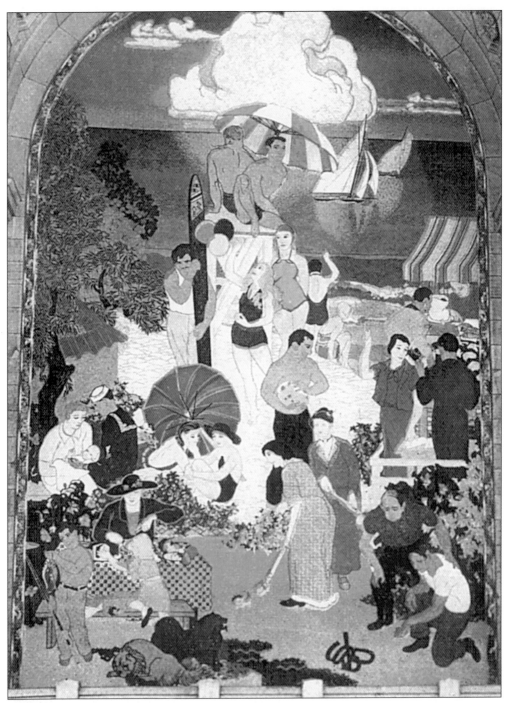

Mosaic Over Entrance, Municipal Auditorium, Long Beach, California.
Commentary on the card reads: "This magnificent and colorful mosaic is truly a work of art. It is an impressive addition to the outstanding Long Beach Municipal Auditorium, one of Southern California's most popular show places, which overlooks the quiet water of Rainbow Lagoon." (P/P: Longshaw Card Co., Los Angeles. No. 270. Postmark: April 1944.)

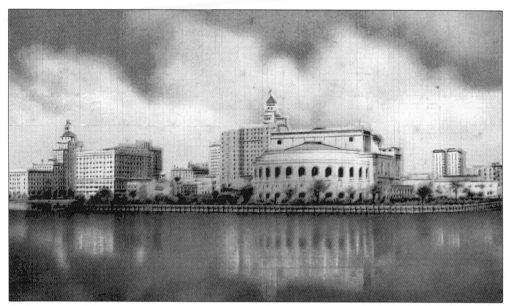

SKYLINE AND MUNICIPAL AUDITORIUM, LONG BEACH, CALIFORNIA. The card text reads: "In a setting unduplicated the world over, the Long Beach Auditorium mirrors its majestic splendor in the quiet waters of the Rainbow Lagoon. Here are held athletic, civic, and social activities of interest and importance." (P/P: Longshaw Card Co., Los Angeles. No. 270. Postmark: April 1944.)

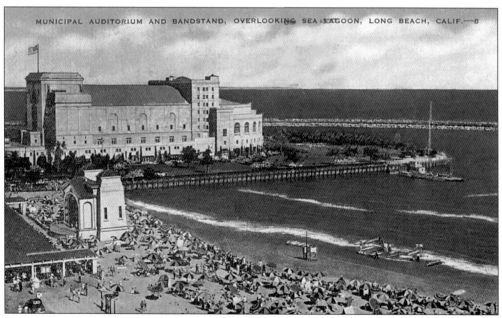

MUNICIPAL AUDITORIUM AND BANDSTAND, OVERLOOKING SEA LAGOON, LONG BEACH, CALIFORNIA. (P/P: Drown News Agency, Long Beach, Cal. No. 8. Postmark: November 1951.)

67

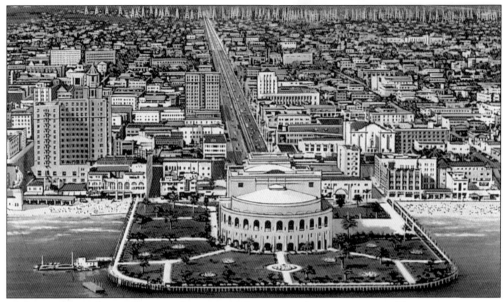

A Portion of Long Beach, Showing Municipal Auditorium in Foreground and Famous Oil Fields in the Distance. (P/P: Western Publishing & Novelty Co., Los Angeles. No. L31.)

Long Beach, Skyline from Rainbow Pier. The Rainbow Pier was a half-circle, 3,800-foot promenade enclosing a quiet lagoon over which the Municipal Auditorium extended. (P/P: Western Publishing & Novelty Co., Los Angeles. No. LB26.)

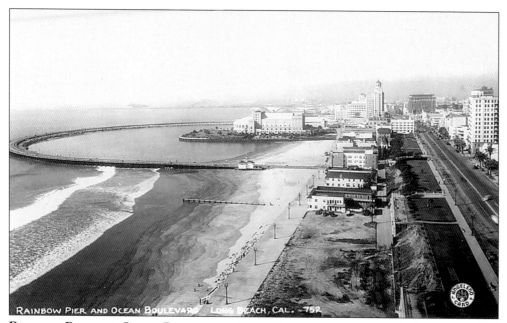

RAINBOW PIER AND OCEAN BOULEVARD, LONG BEACH, CALIFORNIA. The lagoon was filled in during 1955, and the auditorium was torn down in 1975 to allow for the construction of the new convention center and performing arts center. (P/P: Los Angeles Photo Postcard Co., Angeleno Card. No. 752.)

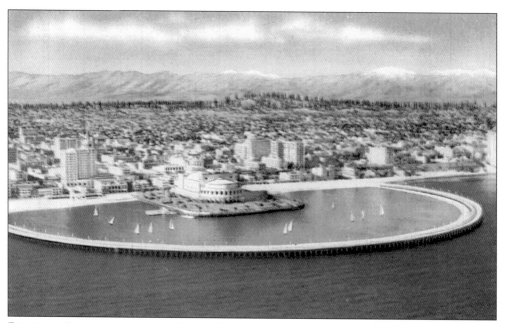

RAINBOW PIER AND SKYLINE, LONG BEACH, CALIFORNIA. (P/P: Longshaw Card Co., Los Angeles. No. 233.)

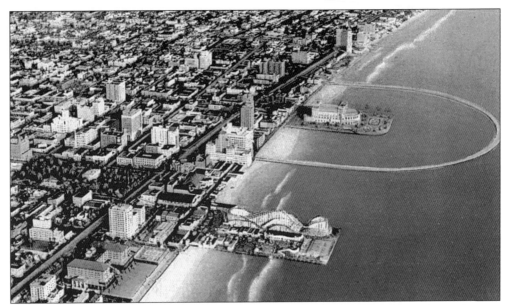

LONG BEACH, SHOWING THE NEW AUDITORIUM AND RAINBOW PIER. (P/P: Western Publishing & Novelty Co., Los Angeles. Spence Air Photo. No. L75.)

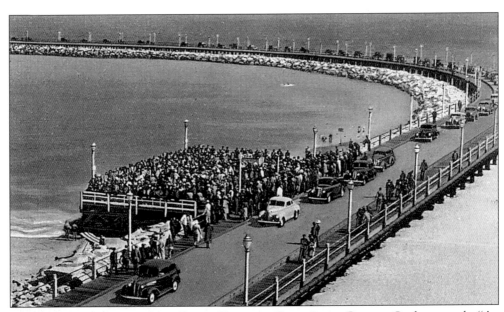

"THE SPIT AND ARGUE CLUB," AND RAINBOW PIER, LONG BEACH. Card text reads: "An open forum of friendly discussions takes place on a large platform on the Rainbow Pier throughout the year. Here anyone is privileged to take the stand and air their views or debate matters of interest, whether political, social, religious or otherwise." (P/P: Western Publishing & Novelty Co., Los Angeles. No. 14. Handwritten date: November 3, 1946.)

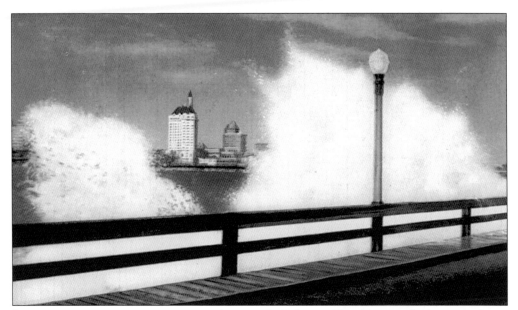

GIANT BREAKERS, LONG BEACH. Card text reads: "The sparkling blue Pacific throws its foamy plumes into the air to the delight of the spectator, and from the Rainbow Pier may be seen the famous clubs and hotels for Long Beach." (P/P: Longshaw Card Co., Los Angeles. No. 218.)

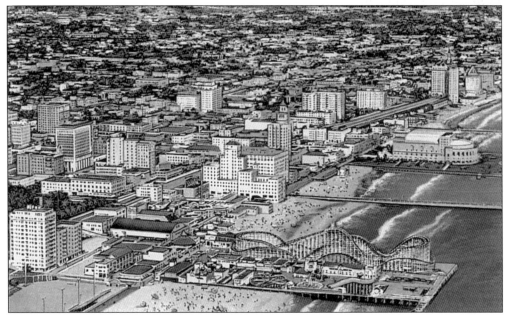

THE BUSINESS AND RECREATIONAL CENTER OF LONG BEACH, CALIFORNIA. (P/P: Western Publishing & Novelty Co., Los Angeles. No. L30.)

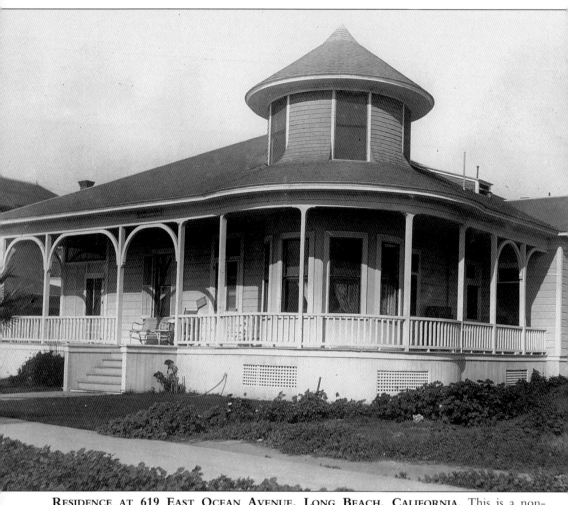

RESIDENCE AT 619 EAST OCEAN AVENUE, LONG BEACH, CALIFORNIA. This is a non-postcard. (P/P: Photo taken 1907–1908 by Belva Snively Heckman, grandmother of the author.)

Four
PARKS, CHURCHES, AND HOMES

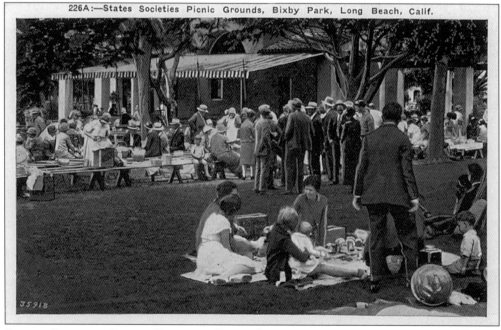

STATES SOCIETIES PICNIC GROUNDS, BIXBY PARK, LONG BEACH, CALIFORNIA. (P/P: M. Kashower, Los Angeles. No 226A.)

Palm Walk, Long Beach Park, Long Beach California

PALM WALK, LONG BEACH PARK. (P/P: Wood's Postcards, Los Angeles. Undivided back.)

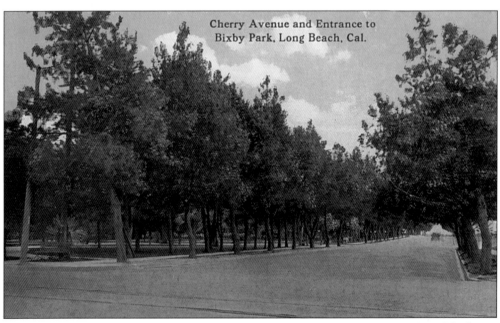

Cherry Avenue and Entrance to
Bixby Park, Long Beach, Cal.

CHERRY AVENUE AND ENTRANCE TO BIXBY PARK, LONG BEACH. Former site of the home of early pioneer, Hotham Bixby. (P/P: Carlin Postcard Co., Los Angeles. No. 35492.)

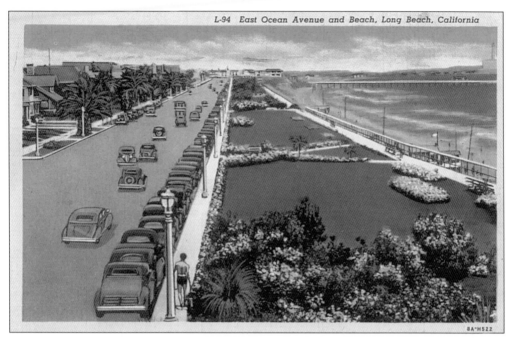

EAST OCEAN AVENUE AND BEACH, LONG BEACH. (P/P: Western Publishing & Novelty Co., Los Angeles. No. L94. Postmark: September 1939.)

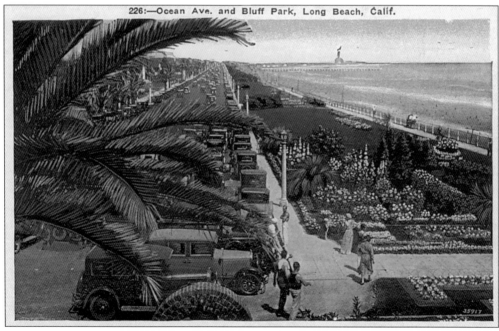

OCEAN AVENUE AND BLUFF PARK, LONG BEACH. (P/P: M. Kashower, Los Angeles. No. 226.)

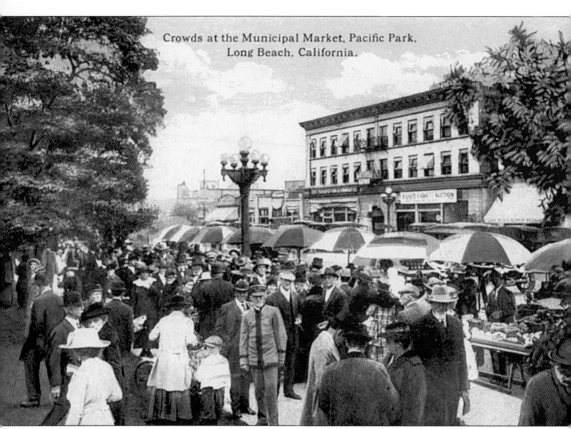

Crowds at the Municipal Market, Pacific Park,
Long Beach, California.

CROWDS AT THE MUNICIPAL MARKET, PACIFIC PARK, LONG BEACH. (P/P: Western Publishing & Novelty Co., Los Angeles. No. L31.)

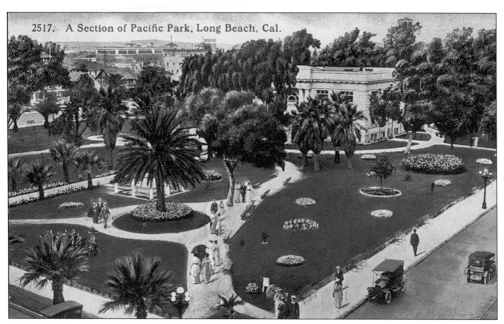

A Section of Pacific Park, Long Beach. (P/P: Western Publishing & Novelty Co., Los Angeles. No. 2517. Postmark: April 1917.)

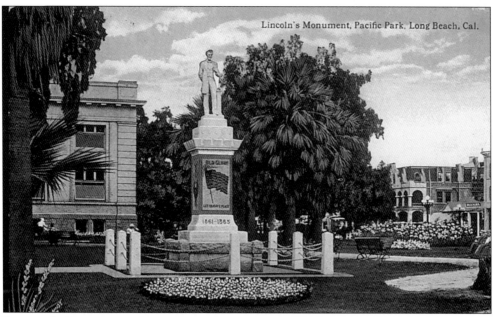

Lincoln's Monument, Pacific Park, Long Beach. (P/P: Western Publishing & Novelty Co., Los Angeles. No. L14. Postmark: January 1928.)

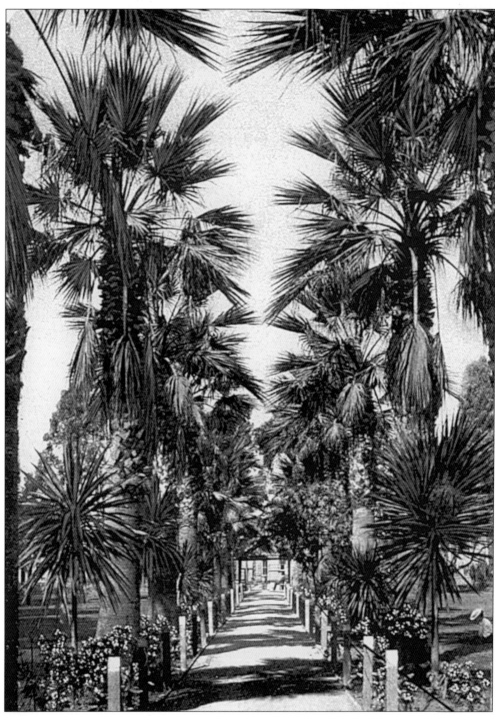

A Winter Scene in the Park at Long Beach. Card text reads: "A beautiful park on the bluff is one of the many attractions of Long Beach that helps to make this town one of the most popular beach towns on the coast." (P/P: M. Rieder, Los Angeles. No. 4576. Made in Germany.)

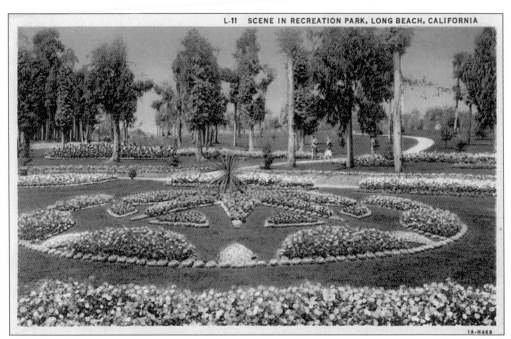

SCENE IN RECREATION PARK, LONG BEACH. (P/P: Western Publishing & Novelty Co., Los Angeles. No. L11.)

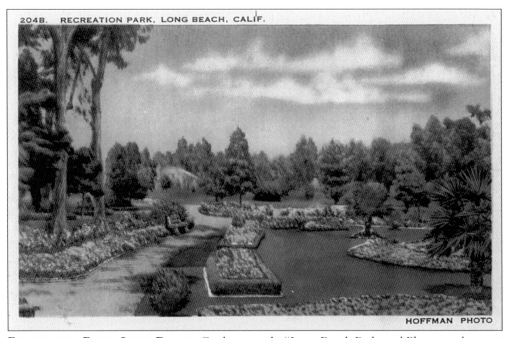

RECREATION PARK, LONG BEACH. Card text reads: "Long Beach Parks and Playgrounds attract visitor and resident alike, and furnish beauty of scenery and recreational programs to all ages." (P/P: Longshaw Card Co., Los Angeles. Hoffman Photo. No. 204B.)

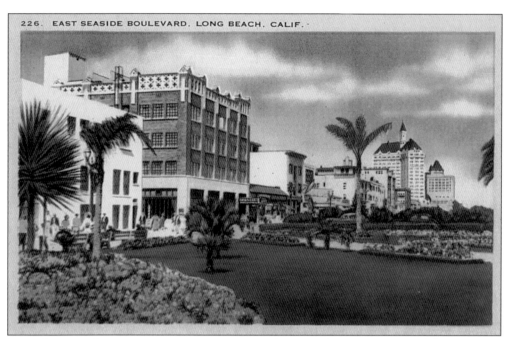

EAST SEASIDE BOULEVARD, LONG BEACH. Card text reads: "In a setting of flower-strewn parks and dazzling beaches, Long Beach proudly displays its large and modern buildings to the interest of its many visitors. (P/P: Longshaw Card Co., Los Angeles. No. 226.)

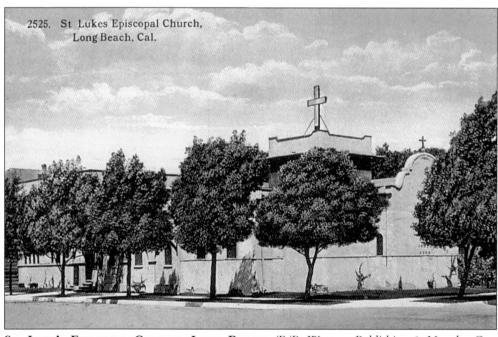

ST. LUKE'S EPISCOPAL CHURCH, LONG BEACH. (P/P: Western Publishing & Novelty Co., Los Angeles. No. 2325.)

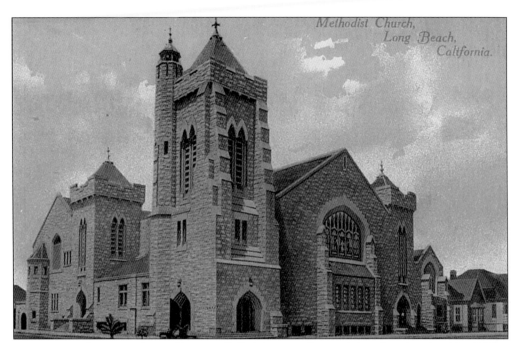

METHODIST CHURCH, LONG BEACH. (P/P: Newman Postcard Co., Los Angeles. No. D8.)

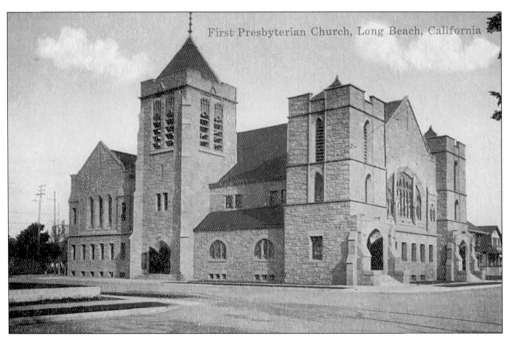

FIRST PRESBYTERIAN CHURCH, LONG BEACH. (P/P: M. Kashower, Los Angeles. No. 500.)

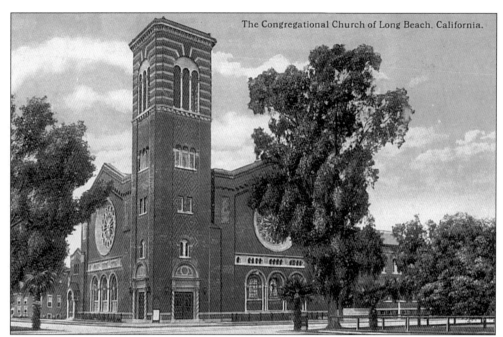

THE CONGREGATIONAL CHURCH OF LONG BEACH, CALIFORNIA. (P/P: Julius J. Hecht. Los Angeles. No. 112.)

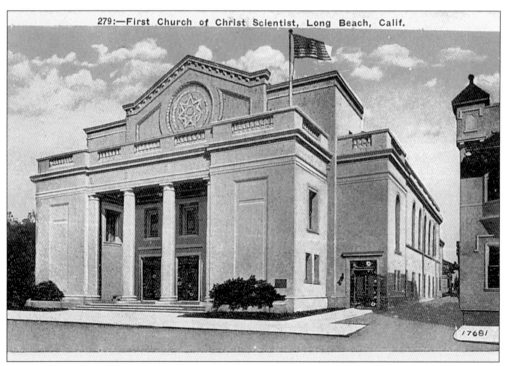

FIRST CHURCH OF CHRIST SCIENTIST, LONG BEACH, CALIFORNIA. (P/P: M. Kashower, Los Angeles. No. 17681.)

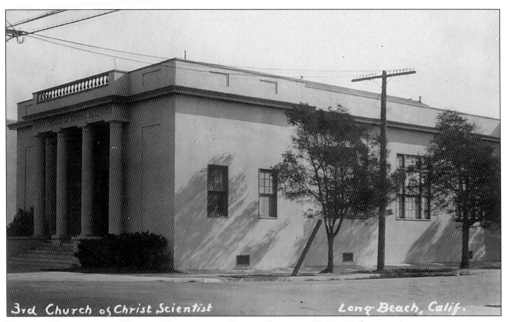

THIRD CHURCH OF CHRIST SCIENTIST, LONG BEACH. (P/P: Unknown.)

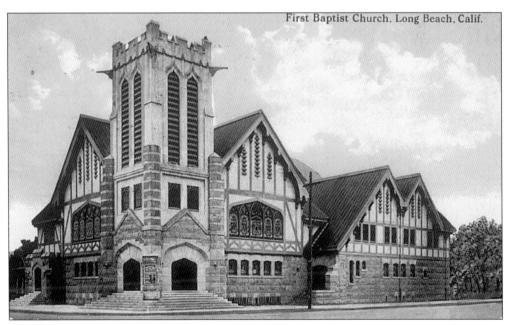

FIRST BAPTIST CHURCH, LONG BEACH. (P/P: Newman Postcard Co., Los Angeles & San Francisco. No. D6. Postmark: October 1916.)

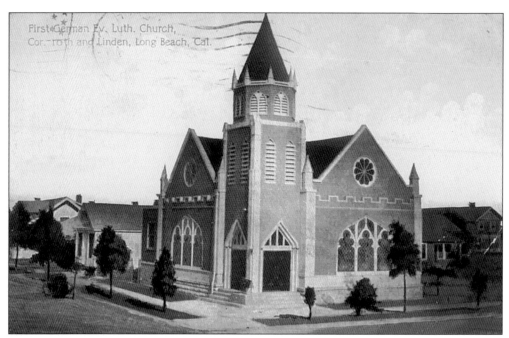

FIRST GERMAN EVANGELICAL LUTHERAN CHURCH, CORNER OF 10TH AND LINDEN STREETS, LONG BEACH. (P/P: Newman Postcard Co., Los Angeles & San Francisco. Postmark: February 1918.)

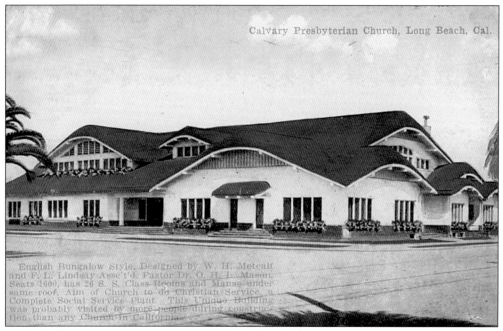

CALVARY PRESBYTERIAN CHURCH, LONG BEACH. Text from the front of the card reads: "English Bungalow Style. . . Seats 1,600, has 26 S.S. Class Rooms and Manse under same roof. . . This Unique Building was probably visited by more people during construction than any other church in California." (P/P: Edward H. Mitchell, San Francisco. Postmark: December.)

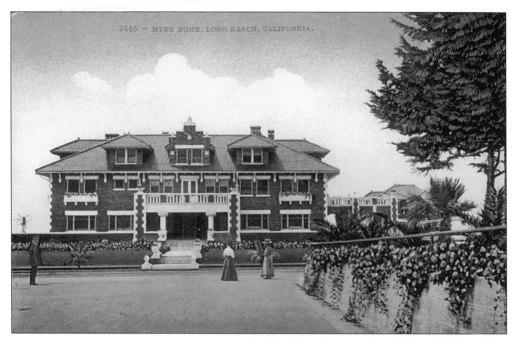

MEYER HOME, LONG BEACH. (P/P: Edward H. Mitchell, San Francisco. No. 2446.)

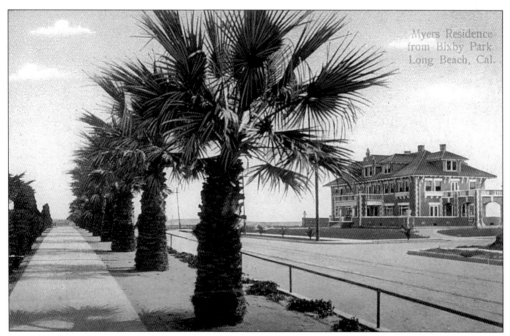

MYERS RESIDENCE FROM BIXBY PARK, LONG BEACH. (P/P: Rieder, Los Angeles. No. 5308. Made in Germany. Handwritten date: Long Beach, December.)

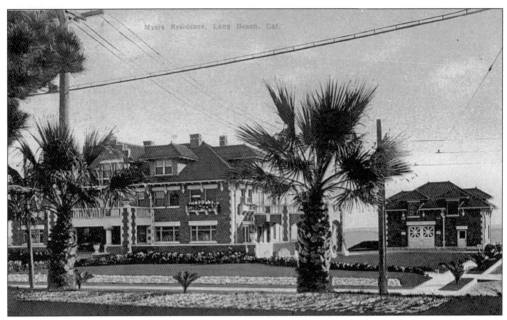

MYERS RESIDENCE, LONG BEACH. (P/P: Los Angeles News Agency, Los Angeles. No. 1. Postmark: September 1911.)

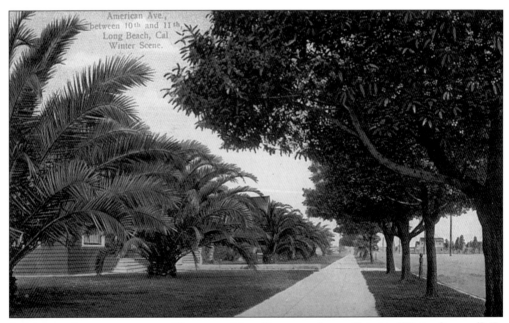

AMERICAN AVENUE BETWEEN 10TH AND 11TH STREETS, LONG BEACH. Winter Scene. (P/P: M. Rieder, Los Angeles. No. 5305. Made in Germany. Handwritten date: December 24, 1909.)

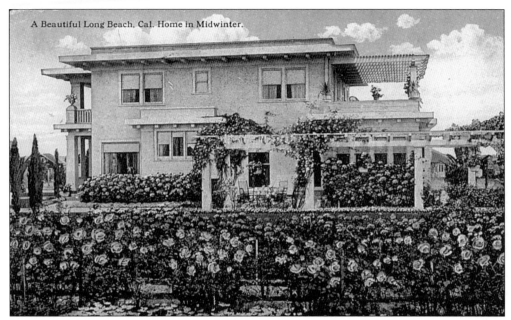

A Beautiful Long Beach, Cal. Home in Midwinter.

A Beautiful Long Beach, California Home in Midwinter. (P/P: Western Publishing & Novelty Co., Los Angeles. No. A59582. Postmark: June 1922.)

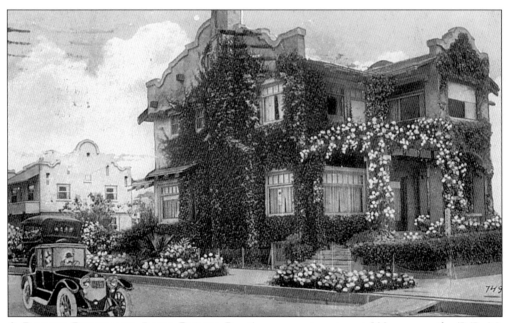

A Pretty Residence, Long Beach. Renting an apartment cost $32 per month. (P/P: M. Kashower. Los Angeles. No. 252. Postmark: January 1925.)

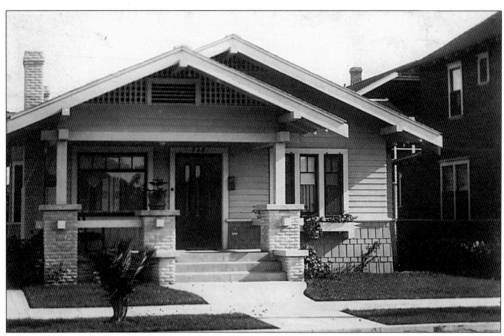

LONG BEACH RESIDENCE, 718 FIFTH STREET. (P/P: Seaside Studio, Long Beach. Postmark: August 1913.)

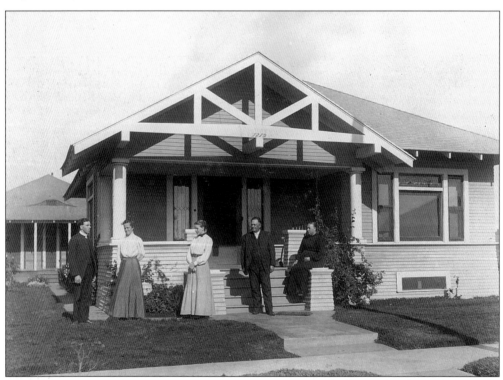

RESIDENCE OF J.M. SHIVELY, LONG BEACH. (Non-postcard. Photo taken by Belva Snively, grandmother of the author, 1908.)

Five
RESORT HOTELS
AND APARTMENTS

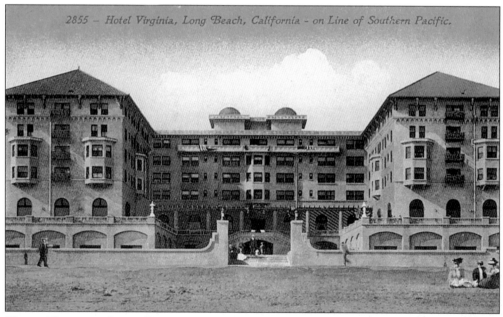

HOTEL VIRGINIA, LONG BEACH, CALIFORNIA—ON LINE OF SOUTHERN PACIFIC. Opened April 1, 1908, at a cost of $25,000. Nine hundred guests were at the opening. (P/P: Edward H. Mitchell, San Francisco, for the Southern Pacific Company. No. 2855.)

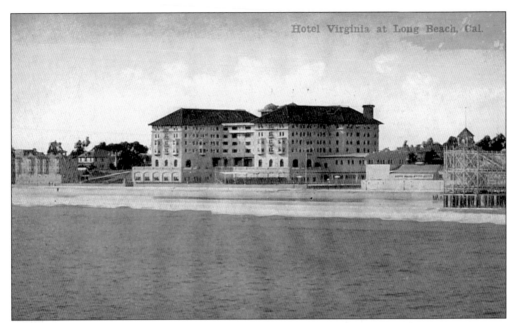

HOTEL VIRGINIA AT LONG BEACH, CALIFORNIA—COMPLIMENTS OF LOS ANGELES CHAMBER OF COMMERCE. This hotel is located on the south side of Ocean Avenue at Magnolia. (P/P: Newman Postcard Co., Los Angeles & San Francisco. No. D1.)

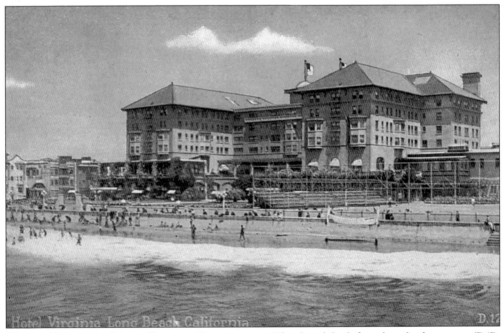

HOTEL VIRGINIA, LONG BEACH, CALIFORNIA. The hotel had four hundred rooms. (P/P: Pacific Novelty Co., San Francisco & Los Angeles. No. D12).

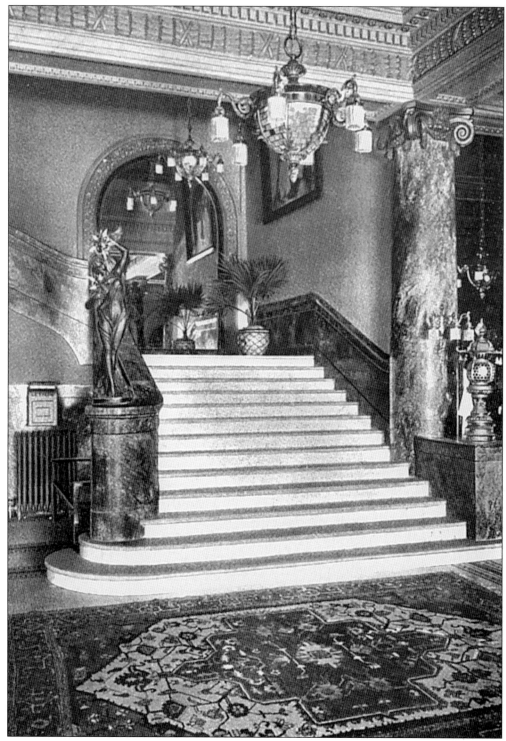

THE STAIRWAY, VIRGINIA HOTEL, LONG BEACH, CALIFORNIA. (P/P: M. Rieder, Los Angeles. No. 5274. Photo only copyrighted by O.A. Bosley, 1908. Made in Germany.)

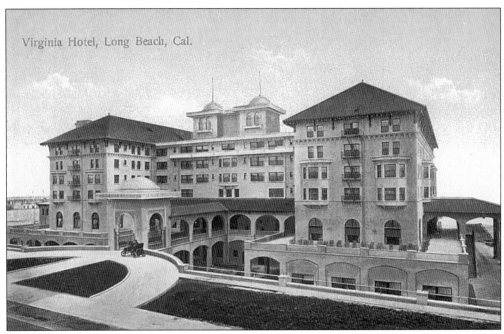

VIRGINIA HOTEL, LONG BEACH, CALIFORNIA. The first transcontinental telephone call between New York and Long Beach was made by a hotel guest. (P/P: M. Rieder, Los Angeles. No. 5115. Made in Germany.)

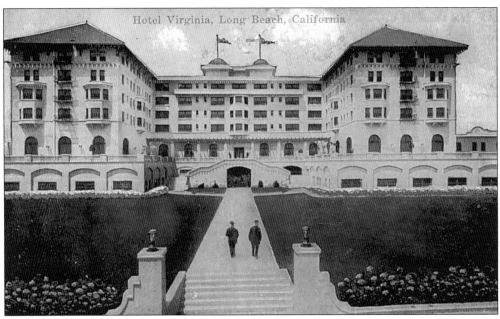

HOTEL VIRGINIA, LONG BEACH, CALIFORNIA. (P/P: M. Kashower, Los Angeles. No. 724. Postmark: December 1920.)

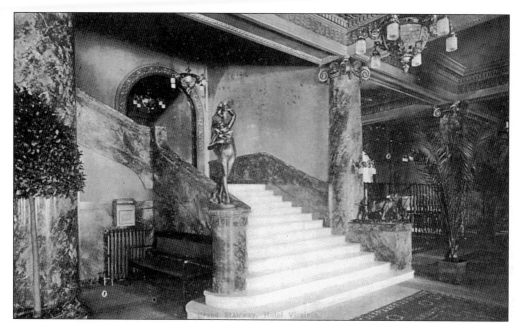

GRAND STAIRCASE, HOTEL VIRGINIA, LONG BEACH, CALIFORNIA. Prominent visitors included President Howard Taft. (P/P: Los Angeles News Co., Los Angeles. No. 13. Postmark: September 1912.)

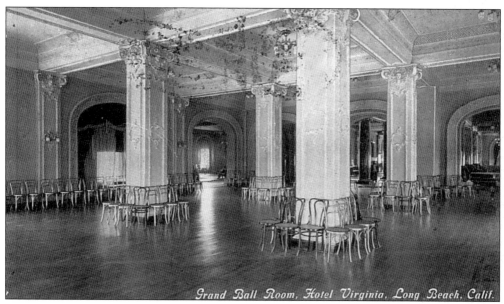

GRAND BALLROOM, HOTEL VIRGINIA, LONG BEACH, CALIFORNIA. (P/P: Benham, Los Angeles. No. 2313. Postmark: July 1919.)

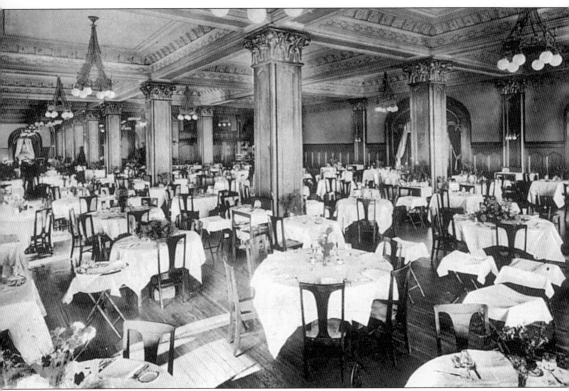

THE DINING ROOM, HOTEL VIRGINIA, LONG BEACH, CALIFORNIA. "The menus were elegantly continental and variable with 65-piece place settings, fine linens, and a waiter for every five guests. The four dining rooms could serve 1,140 at one time." (Loretta Buner, *Shades of the Past*, Historical Society of Long Beach, 1995, P14.) (P/P: George O. Restall, Los Angeles. No LB06. Made in Germany.)

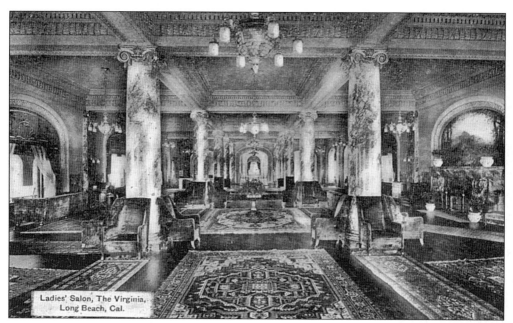

LADIES' SALON, THE VIRGINIA, LONG BEACH, CALIFORNIA. (P/P: Woods, Los Angeles.)

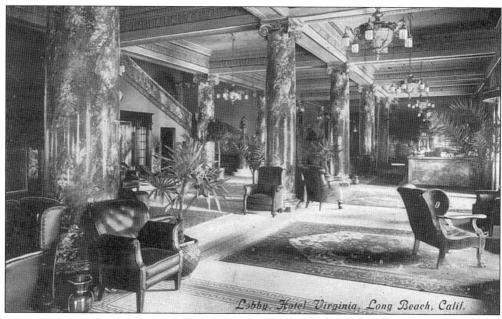

LOBBY, HOTEL VIRGINIA, LONG BEACH, CALIFORNIA. (P/P: Benham Co., Los Angeles. No. 322. Postmark: July 1911.)

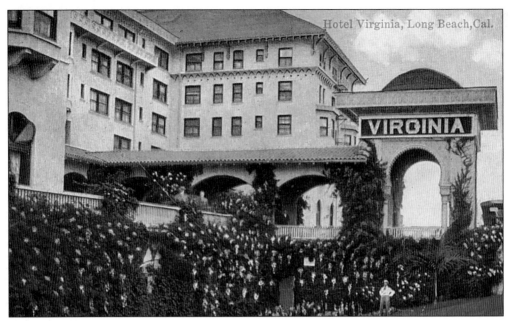

HOTEL VIRGINIA, LONG BEACH, CALIFORNIA. (P/P: M. Kashower, Los Angeles. No. 490.)

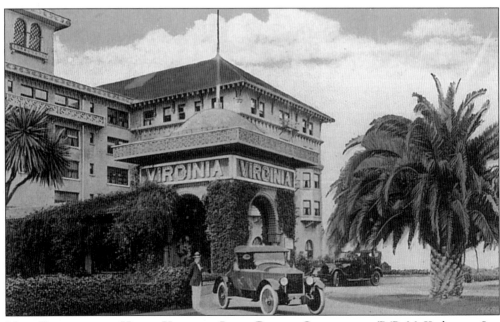

MAIN ENTRANCE TO HOTEL VIRGINIA, LONG BEACH, CALIFORNIA. (P/P: M. Kashower, Los Angeles. No. 228.)

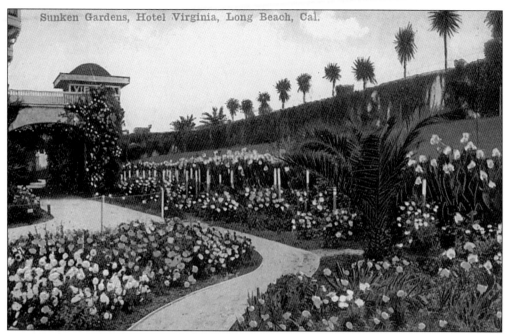

SUNKEN GARDENS, HOTEL VIRGINIA, LONG BEACH, CALIFORNIA. (P/P: Van Ornum, Colorprint, Los Angeles. No. 489.)

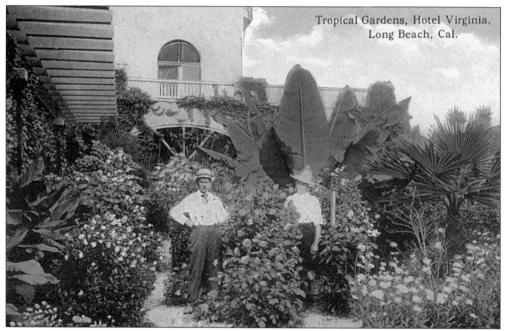

TROPICAL GARDENS, HOTEL VIRGINIA, LONG BEACH, CALIFORNIA. (P/P: Western Publishing & Novelty Co., Los Angeles. No. L31.)

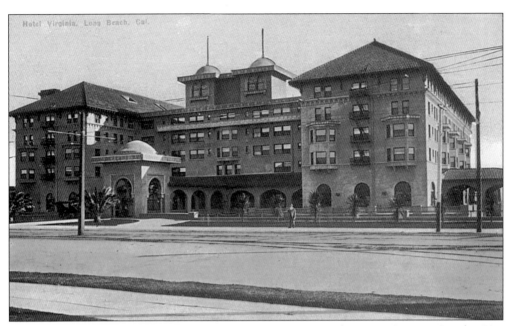

HOTEL VIRGINIA, LONG BEACH, CALIFORNIA. (P/P: Los Angeles News Co., Los Angeles. No. 2057.)

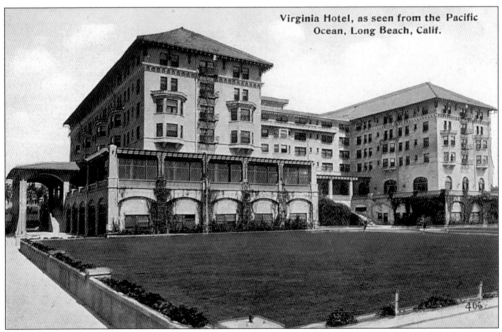

VIRGINIA HOTEL, AS SEEN FROM THE PACIFIC OCEAN, LONG BEACH, CALIFORNIA. The hotel failed during the Depression. It was being torn down in the early 1930s when an earthquake helped finish the job. (P/P: Tichnor Bros., Boston & Los Angeles. No. 406.)

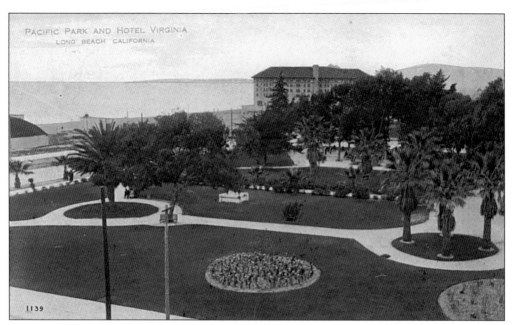

PACIFIC PARK AND HOTEL VIRGINIA, LONG BEACH, CALIFORNIA. (P/P: Benham Co., Los Angeles. No. 1139.)

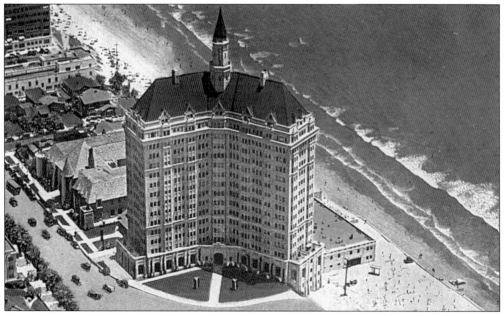

VILLA RIVIERA APARTMENT HOTEL, LONG BEACH, CALIFORNIA. Built in 1929, this 17-story building was known as the Grand Dame of apartment buildings. (P/P: E.C. Kropp, Milwaukee, WI. No. 12150.)

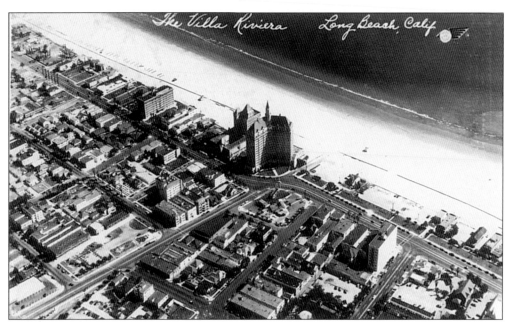

THE VILLA RIVIERA, LONG BEACH, CALIFORNIA. (P/P: Unknown.)

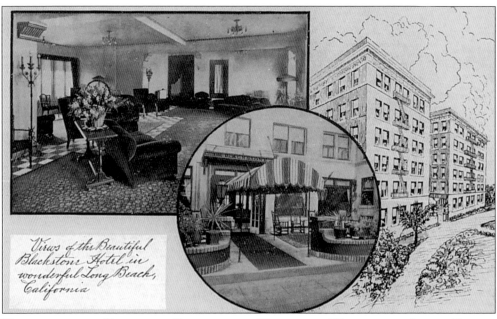

VIEWS OF THE BEAUTIFUL BLACKSTONE HOTEL IN WONDERFUL LONG BEACH, CALIFORNIA. This hotel was built in 1923. (P/P: Unknown.)

HOTEL LAFAYETTE, LONG BEACH, CALIFORNIA. Text on the card reads: "A hotel of distinction catering to the desires and comforts of the discriminating guest. Excellent dining rooms. Free parking. Moderate rates prevail." (P/P: E.C. Kropp, Milwaukee, WI. No. 22855.)

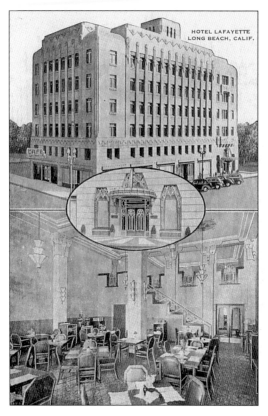

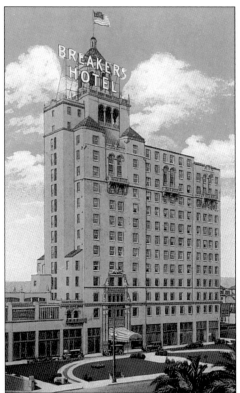

BREAKERS HOTEL, LONG BEACH, CALIFORNIA. This hotel was built in 1925–26. (P/P: Western Publishing & Novelty Co., Los Angeles. Photo by Warren M. Sargent. No. L65.)

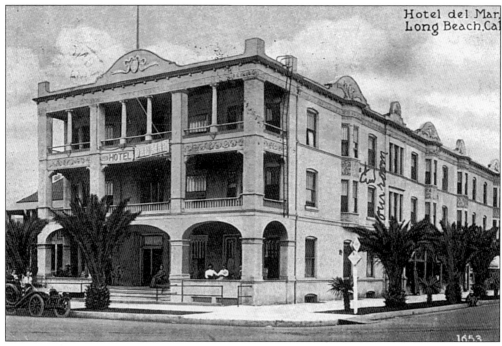

Hotel del Mar, Long Beach, California. (P/P: Edward H. Mitchell, San Francisco. No. 1653. Postmark: March 1913.)

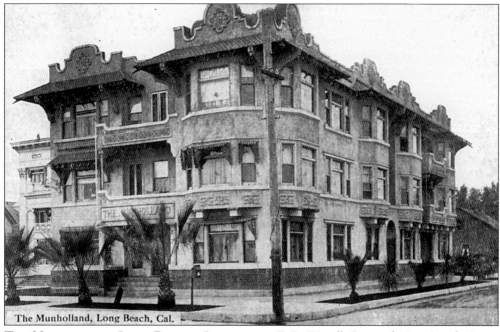

The Munholland, Long Beach, California. (P/P: Wood's Postcards, Los Angeles.)

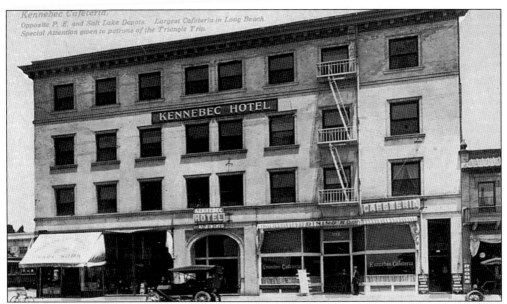

KENNEBEC HOTEL & CAFETERIA. OPPOSITE P.E. AND SALT LAKE CITY DEPOTS. LARGEST CAFETERIA IN LONG BEACH. SPECIAL ATTENTION GIVEN TO PATRONS OF THE TRIANGLE TRIP. Text on the card reads: "Triangle Trolley Trip. Pacific Electric. Last car daily 9:40 a.m. from Pacific Electric Station 6th and Main Streets, Los Angeles. Visiting the South Coast Beaches and Cities—Point Fermin, the Great Government, Breakwater and Lighthouse, San Pedro and the Los Angeles Harbor, Long Beach, Huntington Beach, Santa Ana, and the Orange County beet and celery lands and industries and many other points of interest. Competent Guides. Parlor Car service with Reserved Seats Free. A day of interesting travel and sightseeing for $1.00." (P/P: Benham Co., Los Angeles. No. 3452.)

HOTEL KENNEBEC AND OCEAN AVENUE, LONG BEACH, CALIFORNIA. The written message on the card reads: "This is where I get my meals once in awhile. The lady of the Hotel was buried the other day here." At the corner of Ocean and Pacific Avenues opposite Lincoln Park, this hotel was five stories high. (P/P: Edward H. Mitchell, San Francisco. No. 2447.)

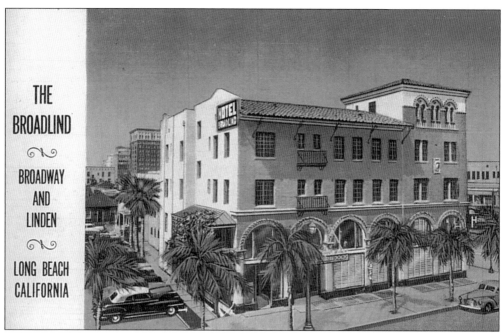

THE BROADLIND, BROADWAY AND LINDEN, LONG BEACH, CALIFORNIA. Text on the card reads: "Just a hop from the beach. Barber shop, Beauty Parlor, and Restaurant in connection. Every room with tile bath and shower. Club Room. The biggest little hotel in Long Beach." It was built in 1928. (P/P: Curteich, Chicago.)

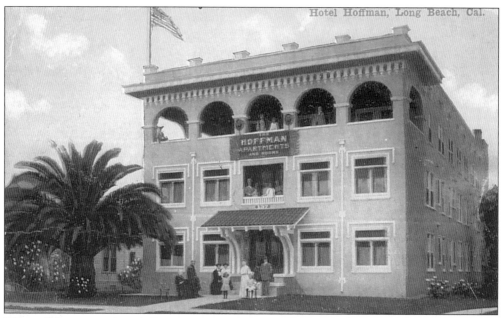

HOTEL HOFFMAN, LONG BEACH, CALIFORNIA. "Hotel Hoffman Apartments and Rooms. High-class, up-to-date and complete in every particular. Delightfully situated one block from the ocean, facing Pacific Park. 137 Cedar Avenue, Long Beach." (P/P: Newman Postcard Co., Los Angeles. Text on card.)

Six
BUILDINGS, BUSINESSES, OIL, AND EARTHQUAKES

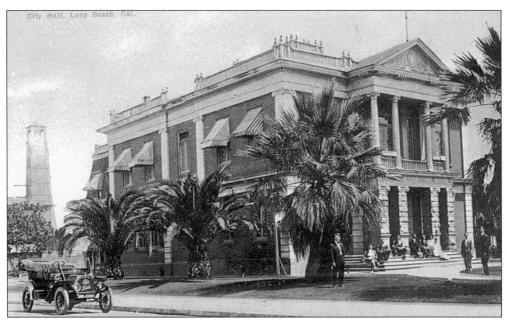

CITY HALL, LONG BEACH, CALIFORNIA. This structure was completed in 1899. (P/P: Los Angeles New Co., Los Angeles. No. M2050.)

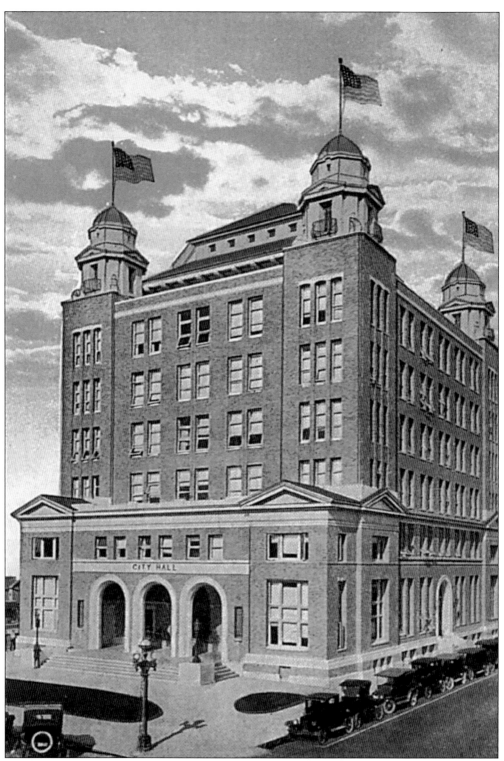

CITY HALL, LONG BEACH, CALIFORNIA. (P/P: S.H. Kress Co., No. 28358.)

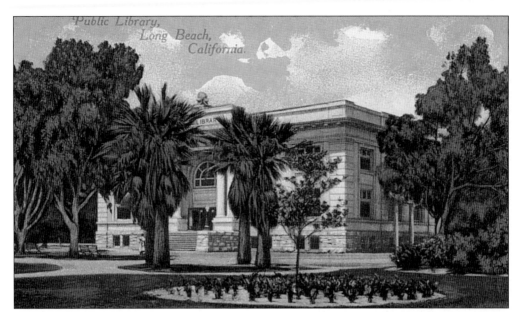

PUBLIC LIBRARY, LONG BEACH, CALIFORNIA. (P/P: Newman Postcard Co., Los Angeles. Handwritten date: Long Beach, January 1910.)

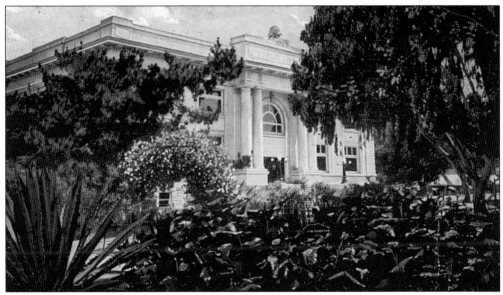

CARNEGIE PUBLIC LIBRARY, LONG BEACH, CALIFORNIA. (P/P: Carlin Postcard Co., Los Angeles. No. A3645. Postmark: September 1913.)

CENTRAL PUBLIC LIBRARY, LONG BEACH, CALIFORNIA. Text on the card reads: "Long Beach is justly proud of its Central Public Library which was built after the earthquake of 1933. It is designed in modern, formal style, decorated with murals from the scenes of American and English literature, and has a collection of 150,000 volumes." (P/P: Longshaw Card Co., Los Angeles. No. 210. Postmark: April 1956.)

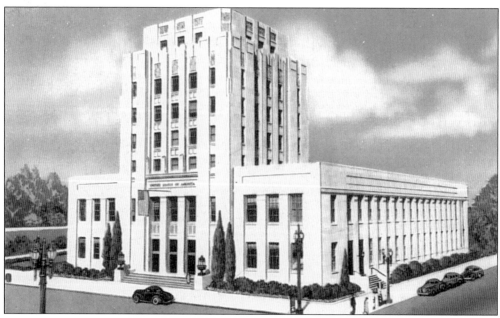

POST OFFICE BUILDING, LONG BEACH, CALIFORNIA. (P/P:Longshaw Card Co., Los Angeles. No. 201A.)

NEW CHAMBER OF COMMERCE BUILDING, LONG BEACH, CALIFORNIA. (P/P: M. Kashower, Los Angeles. No. 206. Postmark: May 1924.)

LONG BEACH DRUG COMPANY, LONG BEACH'S LEADING STORE. Text on the card reads as an advertisement for: "Balloon Route Excursions: $1 no more, visiting 10 beaches, 8 cities, 70 miles, 6 free attractions, National Soldiers Home, Best in the Whole Round World." (P/P: Long Beach Drug Co.)

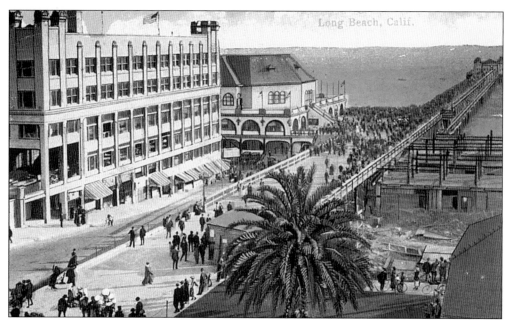

MARKWELL BUILDING AND PLEASURE PIER, LONG BEACH, CALIFORNIA. (P/P: M. Kashower, Los Angeles. No. 103228.)

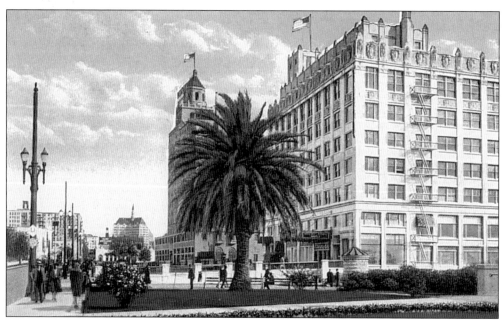

OCEAN AVENUE, SHOWING JERGIN'S TRUST BUILDING AND THE BREAKERS HOTEL, LONG BEACH, CALIFORNIA. (P/P: Western Publishing & Novelty Co., Los Angeles. No. L71.)

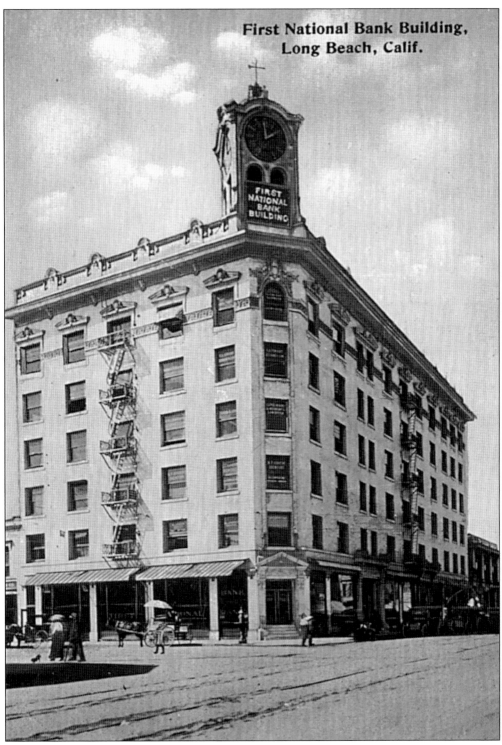

FIRST NATIONAL BANK BUILDING, LONG BEACH, CALIFORNIA. (P/P: Tichnor Brothers, Boston & Los Angeles. No. 409.)

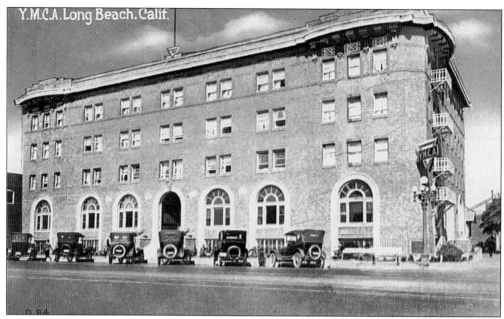

Y.M.C.A. LONG BEACH, CALIFORNIA. (P/P: Pacific Novelty Co., Los Angeles. No. D84.)

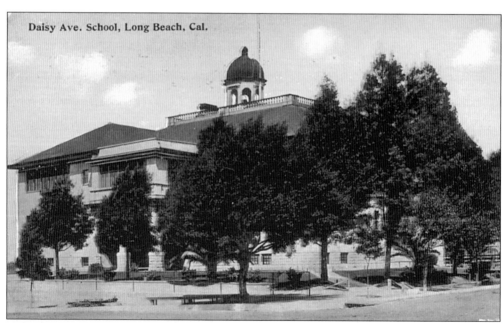

DAISY AVENUE SCHOOL, LONG BEACH, CALIFORNIA. The message on the card reads: "I like California fine and am falling more in love with it every day. The flowers are so beautiful and the ocean is just lovely. I love to watch the breakers by moonlight." (P/P: Western Publishing & Novelty Co., Los Angeles. No. 379. Postmark: November 1913.)

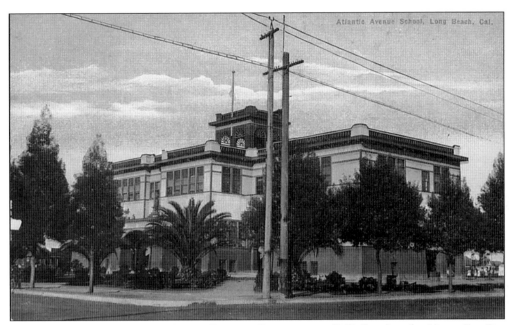

ATLANTIC AVENUE SCHOOL, LONG BEACH, CALIFORNIA. (P/P: Los Angeles News Co., Los Angeles. No. M2052. Postmark: October 1910.)

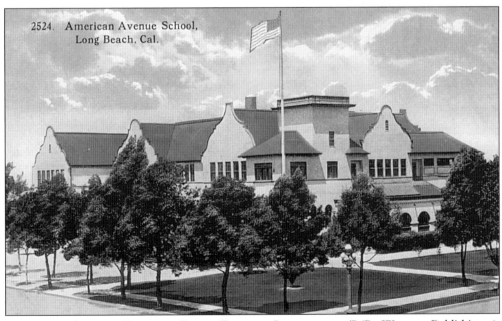

AMERICAN AVENUE SCHOOL, LONG BEACH, CALIFORNIA. (P/P: Western Publishing & Novelty Co., Los Angeles. No. 2524.)

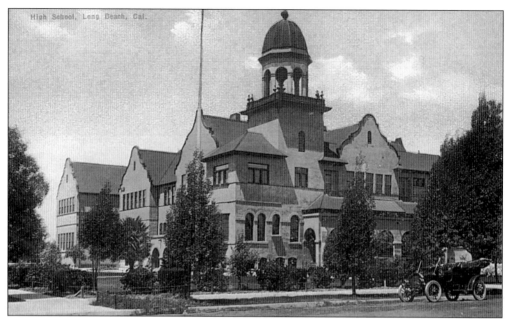

HIGH SCHOOL, LONG BEACH, CALIFORNIA. The high school was built at the corner of 8th and American Streets in 1898. (P/P: Los Angeles News Agency, Los Angeles. No. 2053.)

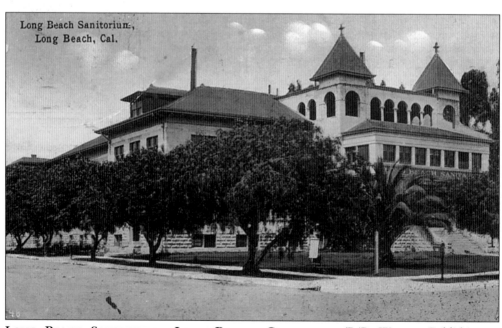

LONG BEACH SANATORIUM, LONG BEACH, CALIFORNIA. (P/P: Western Publishing & Novelty Co., Los Angeles. No. 487. Postmark: February 1917.)

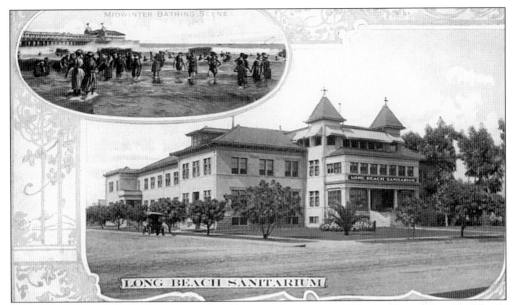

LONG BEACH SANATORIUM, MIDWINTER BATHING SCENE. Text on the card reads: "Battle Creek Sanatorium Methods. The finest and best equipped institution west of Battle Creek [Michigan]. Baths of every description. Electricity in every form. Every luxury and comfort of the strictly modern hotel. Splendid cuisine. . . The sheltered position together with the mild ozonic equalizing influence of the ocean gives us the NEVER HOT, NEVER COLD, but always JUST RIGHT all-the-year-round climate rarely found elsewhere. . . ." (P/P: Newman Postcard Co., Los Angeles & San Francisco.)

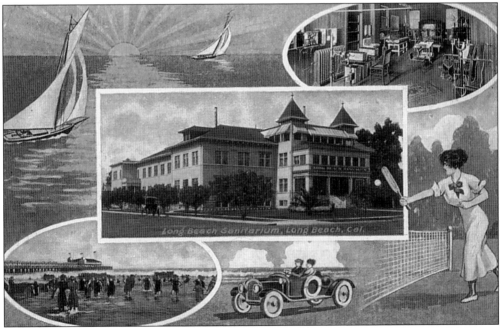

LONG BEACH SANATORIUM. Text on the card reads: "Acknowledged by those 'who know' as CALIFORNIA'S best equipped institution." (P/P: G. Rice & Sons, Printers, Los Angeles.)

115

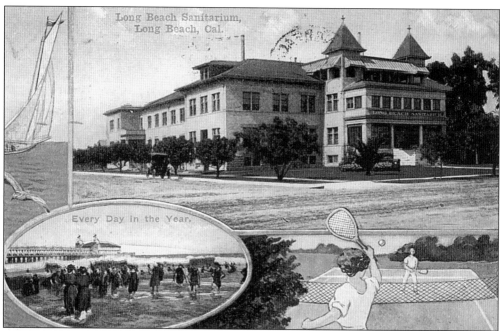

LONG BEACH SANITARIUM. OCEAN BATHING EVERY DAY IN THE YEAR. (P/P: Long Beach Sanitarium. Postmark: June 1913.)

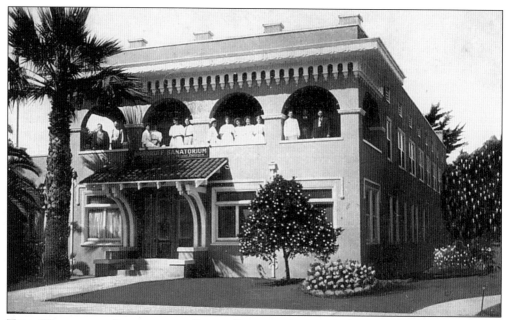

THE WOODRUFF SANITARIUM, LONG BEACH, CALIFORNIA. Text on the card reads: "Beautiful Bright airy rooms in the Sanitarium. 137 Cedar Ave. Rates $.50 to $2.00 a day. . . This completely furnished building has been donated for the Season by Mr. A.P. Hoffman to missionary interests in India, and is under direct management of the missionaries." (P/P: Newman Postcard Co., Los Angeles.)

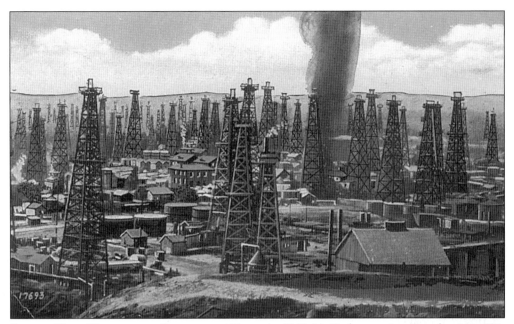

SIGNAL HILL, CALIFORNIA SHOWING A GUSHER. (P/P M. Kashower, Los Angeles. No. 285. Oil was discovered in June 1921.)

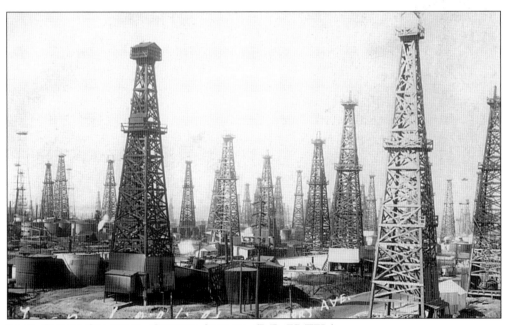

LONG BEACH OIL FIELD, CHERRY AVENUE. (P/P: ERTEL.)

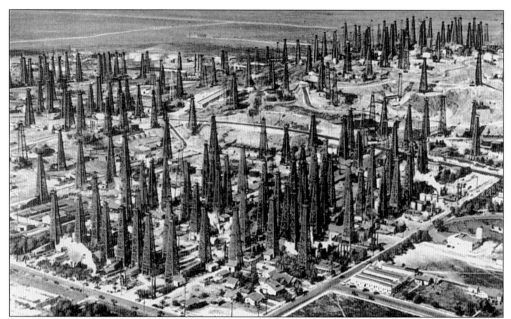

AERIAL VIEW, FAMOUS SIGNAL HILL, CALIFORNIA. (P/P: Tichnor Art Co., Los Angeles. No. T542.)

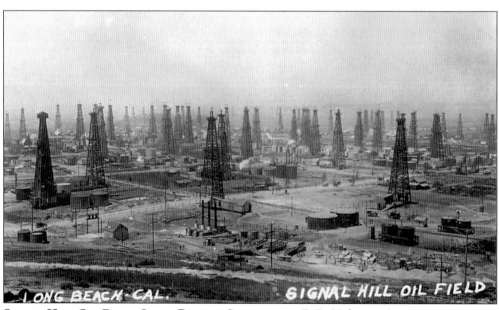

LONG BEACH-CAL. SIGNAL HILL OIL FIELD

SIGNAL HILL OIL FIELD, LONG BEACH, CALIFORNIA. (P/P: Unknown.)

ALL CLOCKS RECORDED THE TIME OF THE QUAKE (5:55 P.M.) The earthquake on March 11, 1933, registered 6.3 on the Richter scale. Fifty-two people were killed and seven hundred injured in Long Beach. Damages were estimated at $45 million. (P/P: Austin Studio, Long Beach. No. 105.)

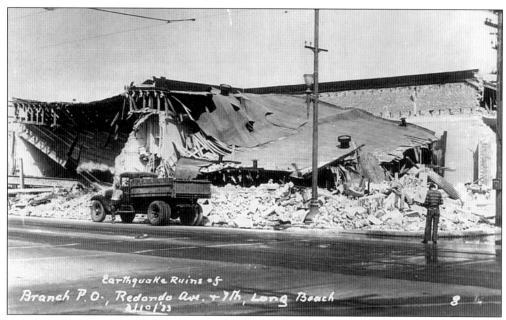

EARTHQUAKE RUINS OF BRANCH P.O., REDONDO AVENUE AND 7TH STREET, LONG BEACH, MARCH 10, 1933. (P/P: Unknown. No. 8.)

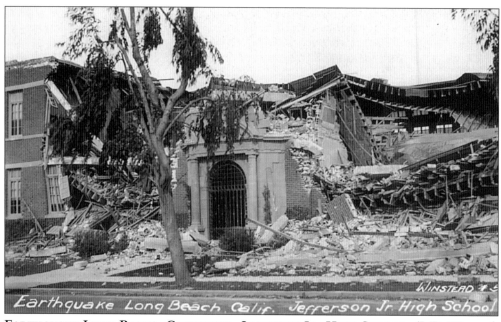

EARTHQUAKE LONG BEACH, CALIFORNIA, JEFFERSON JR. HIGH SCHOOL. (P/P: Winstead. No. 52.)

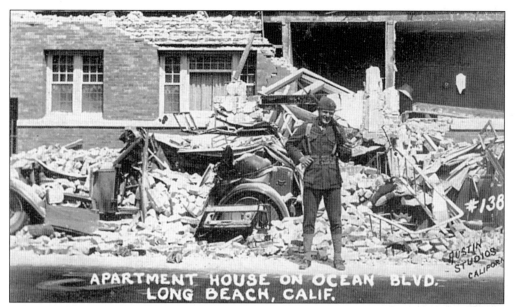

APARTMENT HOUSE ON OCEAN BOULEVARD, LONG BEACH, CALIFORNIA. (P/P: Austin Studio, Long Beach. No. 138.)

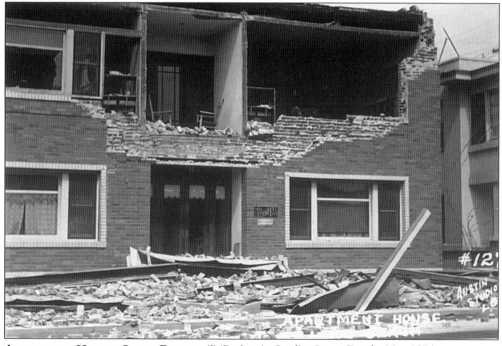

APARTMENT HOUSE, LONG BEACH. (P/P: Austin Studio, Long Beach. No. 127.)

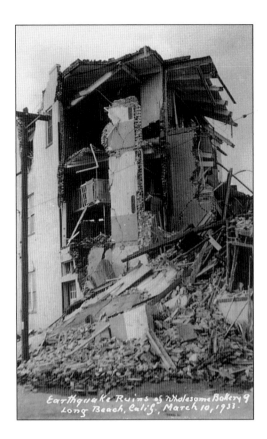

EARTHQUAKE RUINS OF WHOLESOME BAKERY, LONG BEACH, CALIFORNIA, MARCH 10, 1933. (P/P: Unknown. No. 9.)

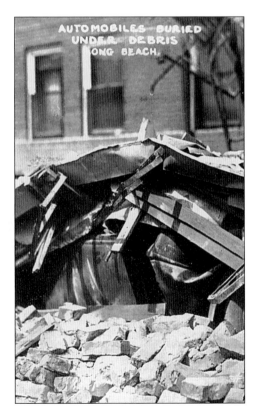

AUTOMOBILES BURIED UNDER DEBRIS, LONG BEACH. (P/P: Unknown.)

122

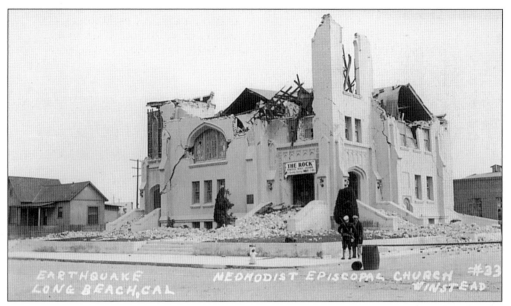

EARTHQUAKE, LONG BEACH, CALIFORNIA, METHODIST EPISCOPAL CHURCH. The soldier was on duty to prevent looting. (P/P: Winstead, No. 33.)

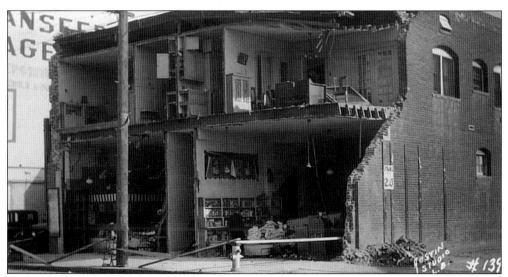

APARTMENT AND STORE, ANAHEIM BOULEVARD, LONG BEACH. NON-POSTCARD. (P/P: Austin Studio, Long Beach, No. 139.)

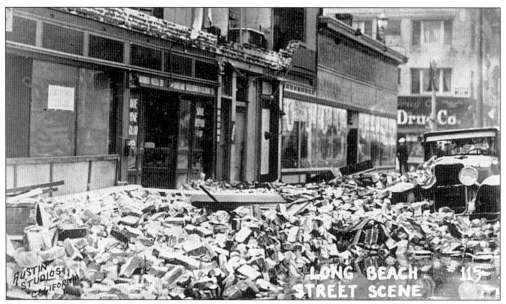

Long Beach Street Scene. (P/P: Austin Studio, Long Beach. No. 115.)

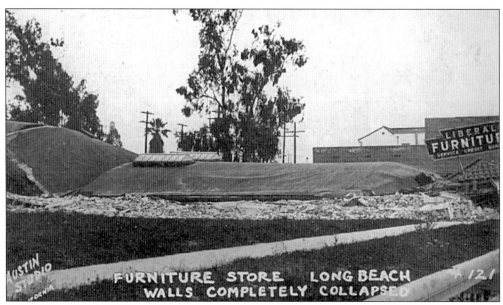

Furniture Store, Long Beach, Walls Completely Collapsed. (P/P: Austin Studio, Long Beach. No. 121.)

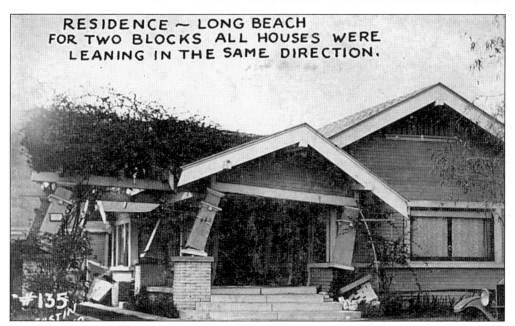

RESIDENCE—LONG BEACH. For two blocks, all houses were leaning in the same direction. (P/P: Austin Studio. No. 135.)

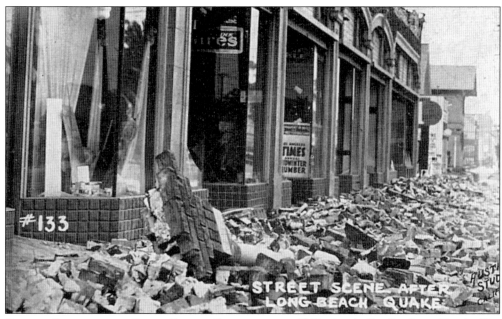

STREET SCENE AFTER LONG BEACH EARTHQUAKE. (P/P: Austin Studio, Long Beach. No. 133.)

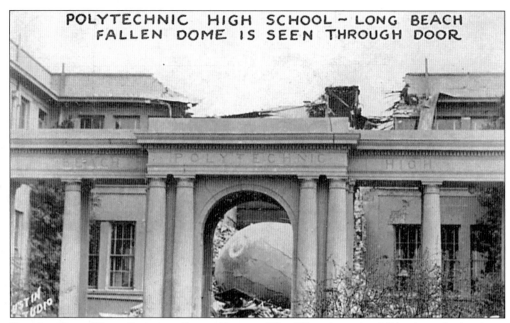

POLYTECHNIC HIGH SCHOOL, LONG BEACH. The fallen dome is visible through the door. (P/P: Austin Studio, Long Beach. No. 134.)

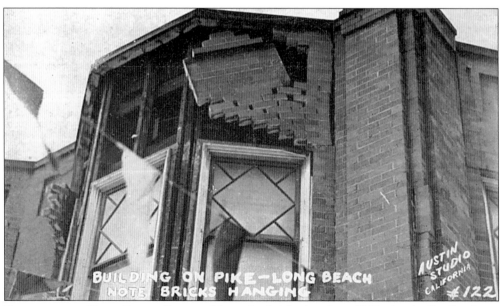

BUILDING ON PIKE—LONG BEACH. Note the bricks hanging. (P/P: Austin Studio, Long Beach. No. 122.)

ON THE BEACH IN FRONT OF THE BEACH HOUSE, LONG BEACH, CALIFORNIA, 1908. Belva Snively, on the right, is the grandmother of the author. This is a non-postcard. (P/P: Family Photo.)

DEDICATION

Dedicated to the memory of my grandparents.

Clark M. Heckman, 1887–1976

and

Belva E. Snively Heckman, 1886–1984

As young people, they had each visited California and Long Beach in 1907 and 1908. They married in Illinois in 1909, and made California their permanent home in 1910, living first in Long Beach.

INDEX OF PUBLISHERS AND PHOTOGRAPHERS